Willy Pogany

The Art of
Drawing

REVISED AND ENLARGED EDITION
INCLUDING
SKETCHES AND STUDIES

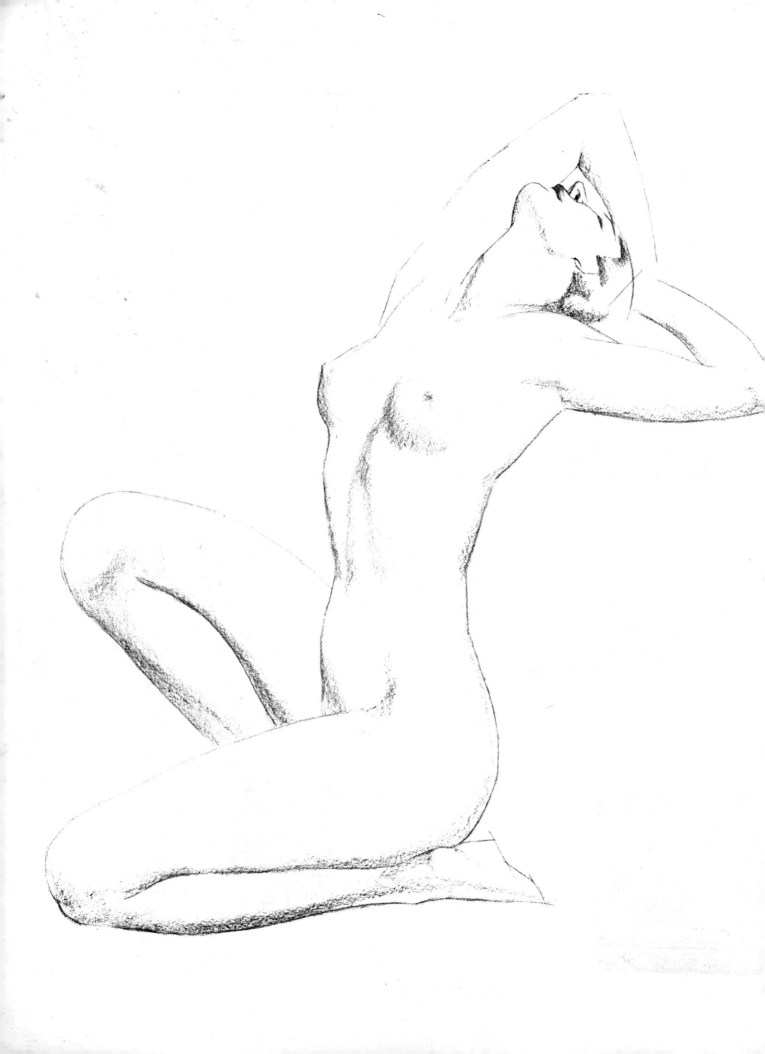

Willy Pogany's

The Art of Drawing

Madison Books
Lanham • New York • London

TO
Elaine

CONTENTS

Published in the United States of America
by Madison Books

© 1996 by Madison Books
Published in 1972 by Littlefield Adams & Co.

Library of Congress Cataloging-in-Publication Data
Pogány, Willy, 1882-1955.
The art of drawing / Willy Pogány.—Rev. and enl. ed.
including sketches and studies.
p. cm.
1. Drawing—Technique. I. Title.
NC650.P6 1996 741.2—dc20 96–13974 CIP

ISBN 1-56833-059-6 (pbk. : alk. paper)

INTRODUCTION

THE aim of this book is to point the way for those who want to learn to draw. I have endeavored to convey to the student the *main principles* in a simple, constructive way. Follow the sequences as laid out in these lessons. Begin with the Dot and follow through conscientiously to the last page. You will be pleasantly surprised at the results!

And now a few words of advice:

Remember it is *your brain* that *directs your hands*. Study the objects you want to draw and you will be able to work more constructively.

Drawing needs plenty of concentration, but *sustained* concentration will tend to tire your perception and lessen your ability. Therefore, it is advisable to step back frequently from your work. This will not only rest you, but will refresh your flagging observation.

Always be sure your paper is clean. *Never* draw on dirty or untidy paper.

If you find your drawing getting smudgy it is much better to start it over again on a clean sheet or, better still, start your sketch on tracing-paper which you fasten to your drawing-paper with scotch tape. Draw as far as you can without much correction.

Then cover your drawing with a clean piece of tracing-paper and continue your drawing through the new tracing-paper making your corrections at the same time.

Continue this method of tracing and correcting your drawing as often as necessary, always placing clean tracing-paper over the previous drawing until you are quite satisfied with your work.

Remove the tracings and lay them side-by-side in proper sequence.

This will enable you to judge, step-by-step, how your drawing progressed.

Another good way of "checking up" is to look at your tracings from the *reverse* side. This will show all your mistakes clearly.

Use a medium-soft pencil. I would suggest "B" "2B" or "No. 1" for your studies.

A pencil that is *too hard* makes a timid drawing, and one that is *too soft* makes the beginner's work rather smudgy.

Hold your pencil firmly but lightly.

Don't plough furrows into your paper.

A good idea while you are drawing is to keep on directing yourself — aloud, if you like. For example: "This line curves here from right to left . . . up or down, etc." (as the case may be).

Or: "This line is vertical, this line is almost horizontal, this line stops about here, etc."

This may seem rather silly but it will help you more than you think.

When copying the drawings in this book, draw them in a larger size. This will help you with your details.

Avoid a *defeatist attitude*. You can do anything you *really* want to do.

Study honestly. Don't try to be too clever at first.

A sound knowledge of drawing should be acquired before developing a personal style. Good Luck to you!

THE DOT

A dot is the simplest thing to draw — so let us begin with the dot.

Take a small writing pad.

Tear out a couple of pages.

Draw a dot anywhere on one of these blank pages.

LIKE THIS

BLANK PAGE

Now try to draw a dot on the other blank page in *exactly* the same position.

Do not trace. Do not measure — except with your eye.

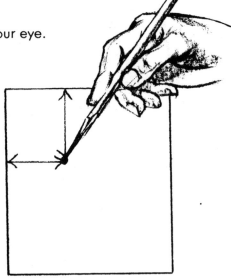

You can see how wrong it would be to place the dot in any one of these positions.

BUT

If you judge with your eye the right distance from the edge of the paper, your dot will be in the right spot.

Next make several dots at random

on a clean page —

something like this ⟶

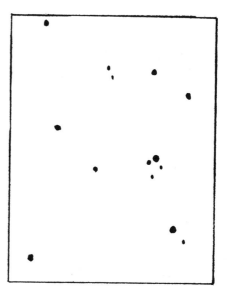

Then copy all of them on a clean sheet.

Do not measure or trace —

just try to judge the correct distances.

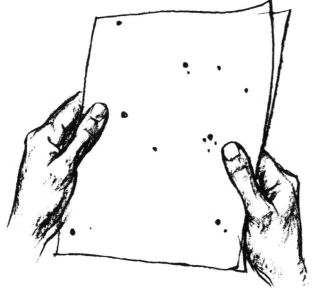

To check the accuracy of your copy place it *over* the original dots and hold both up towards the light. Note your mistakes.

Practice this simple exercise until you come close to perfection. This practice will aid greatly in developing your judgment of Distance, Direction and Proportion.

PERSPECTIVE

We *know* that a cube has six sides.

We *know* also that each side is a perfect square, but if we draw a cube as we *know* it to be, it does not look like a cube.

For example, here are six perfect squares but this drawing does not *look* like a cube.

We *know* that a man has a front and a back, but we have never *seen* both front and back at the same time.

We *know* that a tin can has a circular top and a circular bottom of equal size, but we must admit that we never have *seen* a tin can like this.

We *know* that the house in the distance is considerably larger than the man in the foreground.

We know also that the mountain in the far distance is much larger than the house, but we *see* the man larger than the house and we *see* the house larger than the mountain.

Objects near us *seem* larger and those in the distance *seem* smaller.

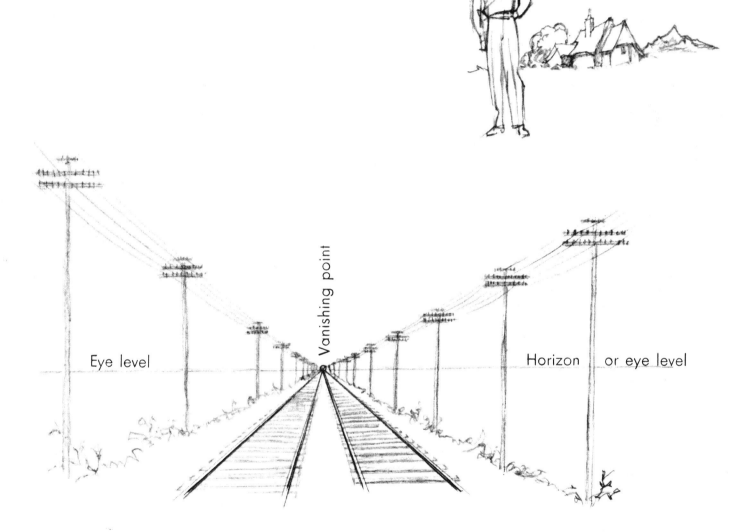

Vanishing point

Eye level

Horizon or eye level

We *know* that the tracks are parallel.

We *know* too that they are the same distance apart all along the line.

We *know* that the telegraph poles are all about equal in height.

Still we *see* the tracks getting nearer and nearer to one another, and we *see* the poles getting smaller and smaller the farther they recede until finally the tracks and the poles seem to disappear into a point.

The point into which parallel lines converge is called a VANISHING POINT.

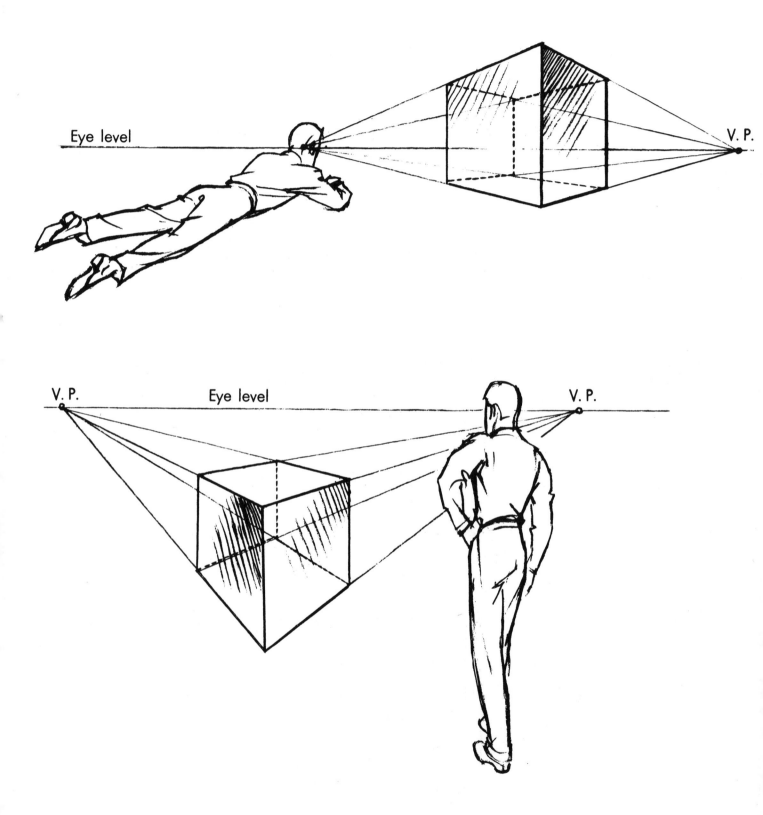

Eye level

V. P.

V. P. Eye level V. P.

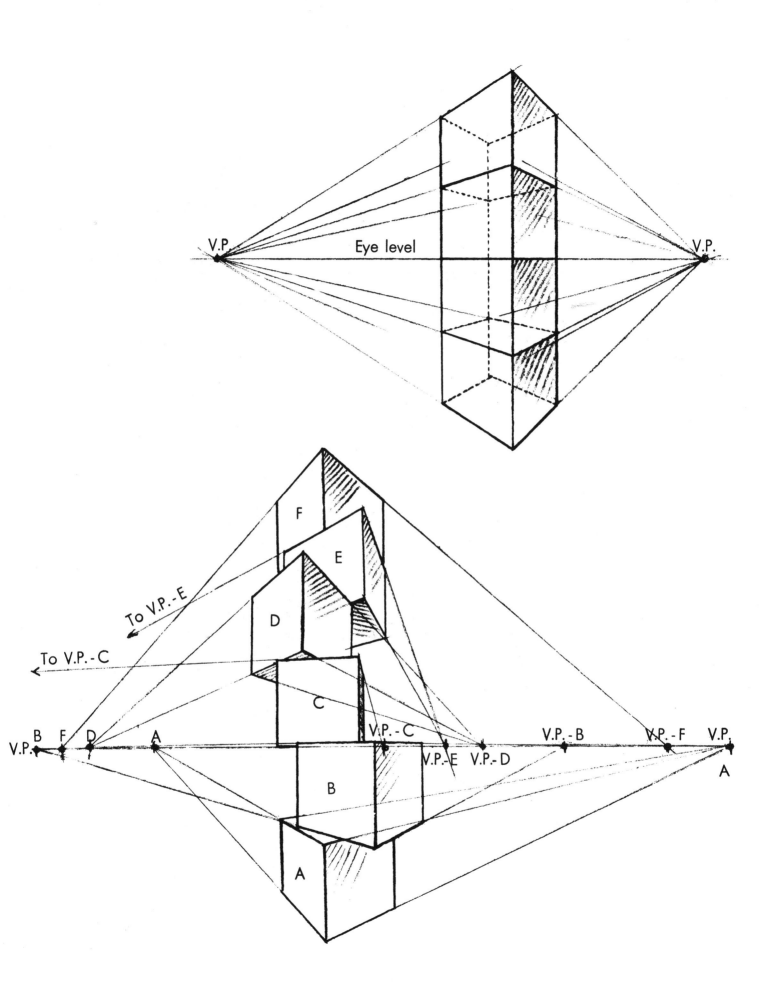

V.P. Eye level V.P.

To V.P.-E

To V.P.-C

F

E

D

C

V.P.-C

V.P. B F D A V.P.-E V.P.-D V.P.-B V.P.-F V.P.

B A

A

Here is a simple way to find the center of a square or an oblong.
Draw the diagonals and they will intersect in the center.

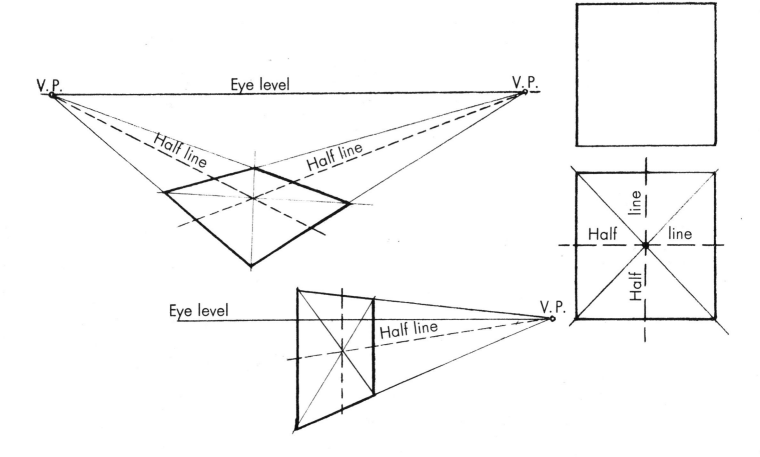

These diagrams show how to repeat squares or oblongs in perspective.

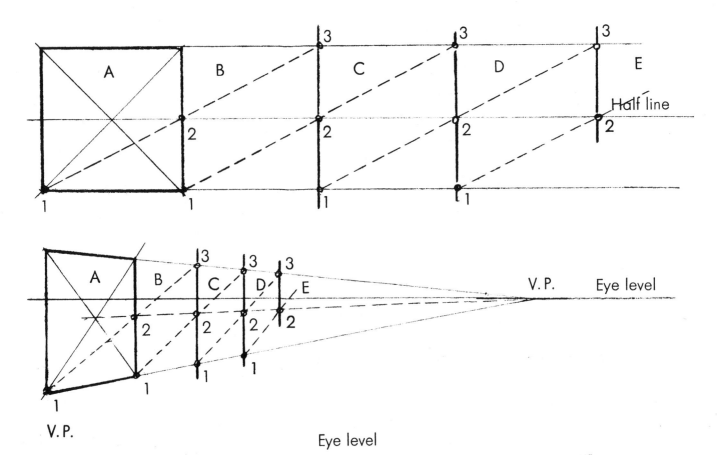

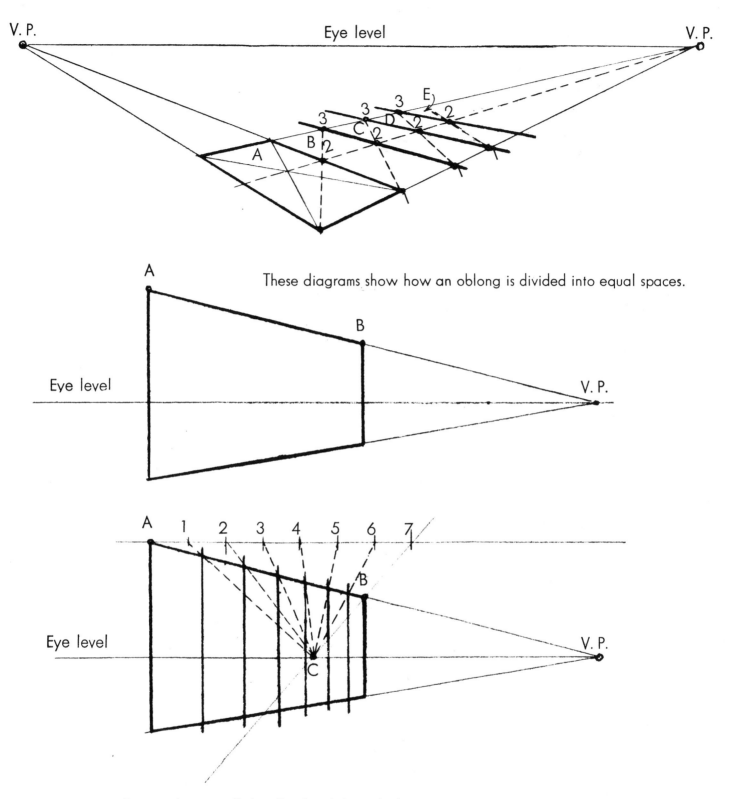

V. P. Eye level V. P.

These diagrams show how an oblong is divided into equal spaces.

Eye level

Eye level

Draw a line parallel to Eye level through A.

Mark equally the desired number of measurements on this line.

Draw a line from the last measurement through corner B to the Eye level.

Draw all your dividing lines to this point C.

Where these converging lines cross A-B will be your points of division.

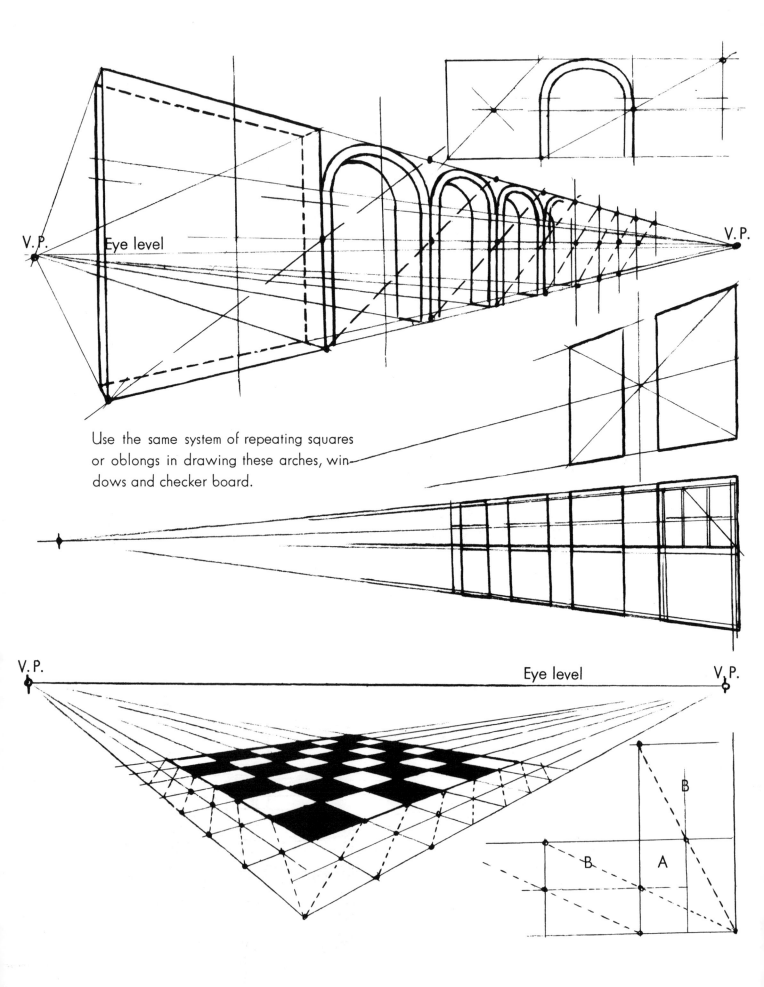

V.P.

Eye level

Use the same system of repeating squares
or oblongs in drawing these arches, win-
dows and checker board.

V.P.

V.P.

Eye level

V.P.

B

B A

14

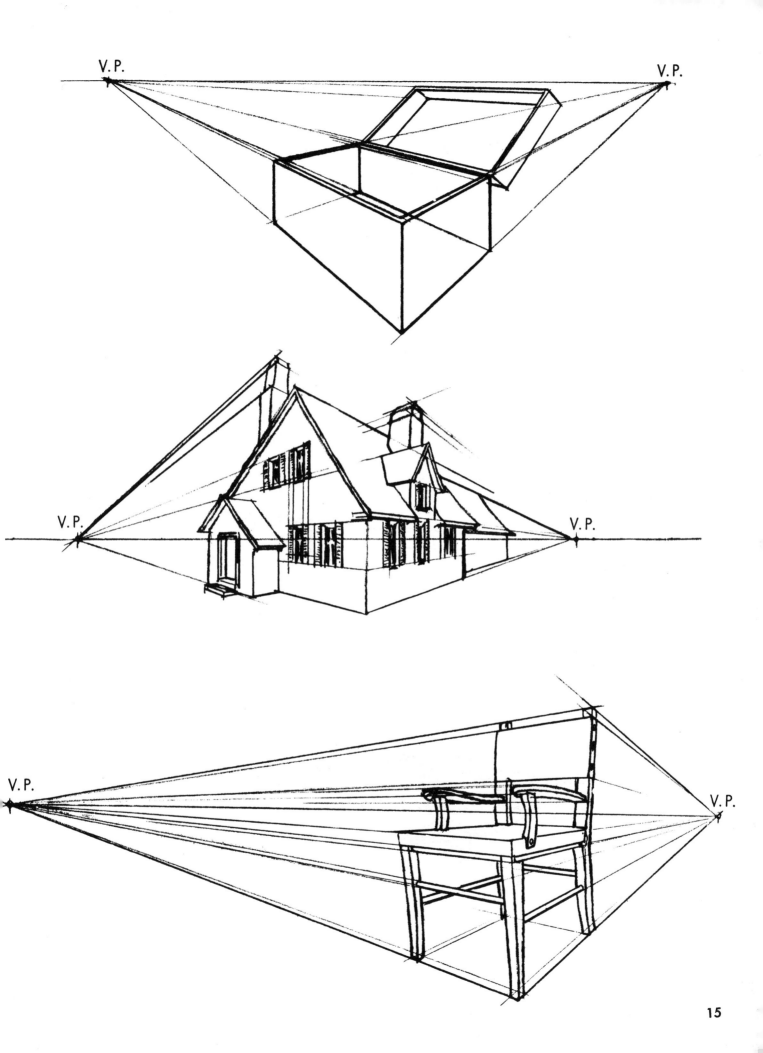

V.P.　　　　　　　　　　V.P.

V.P.　　　　　　　　　　V.P.

V.P.　　　　　　　　　　V.P.

15

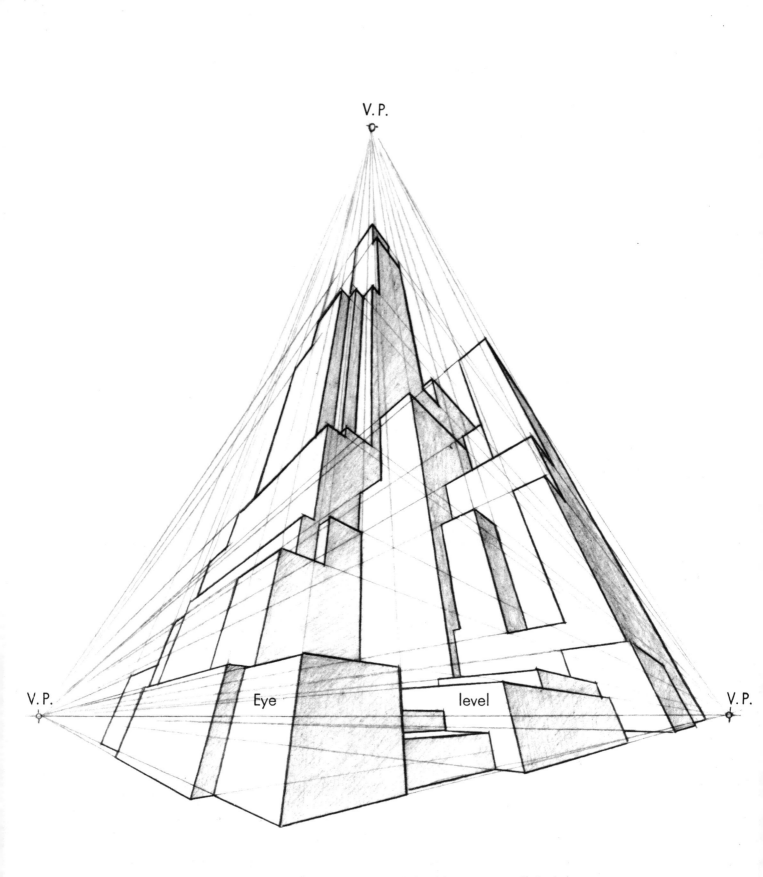

V.P.

V.P. Eye level V.P.

If you look *up* at a group of high buildings you will find the
center vanishing point far *above* your eye level.

When looking *down*, your main vanishing point is *below* eye level.

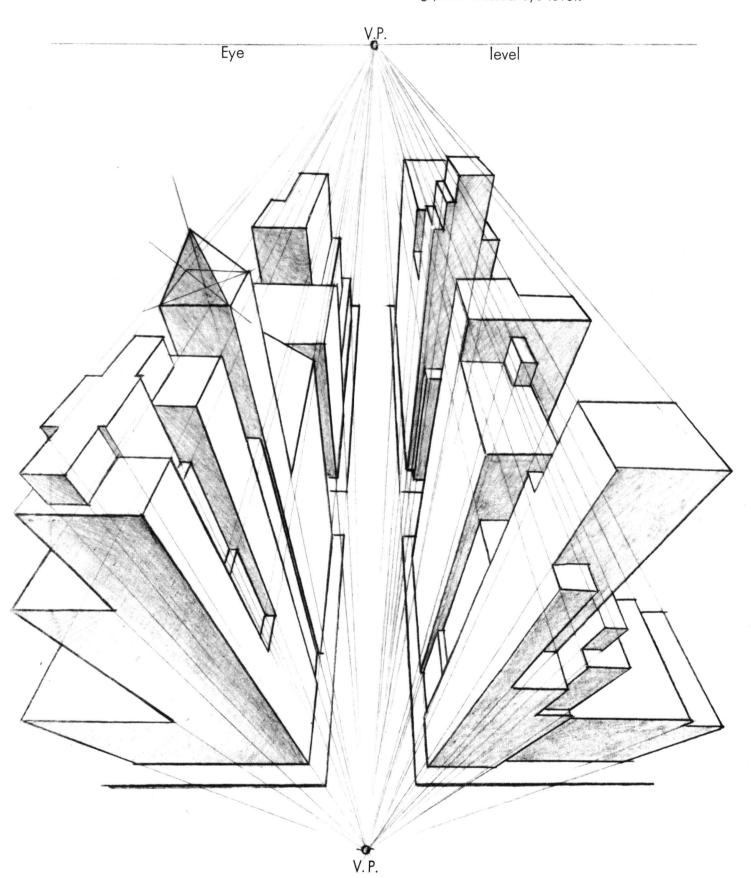

Eye V.P. level

V.P.

PERSPECTIVE DRAWING OF A CYLINDER.

Note that the circles seem flatter as they come nearer to eye level.

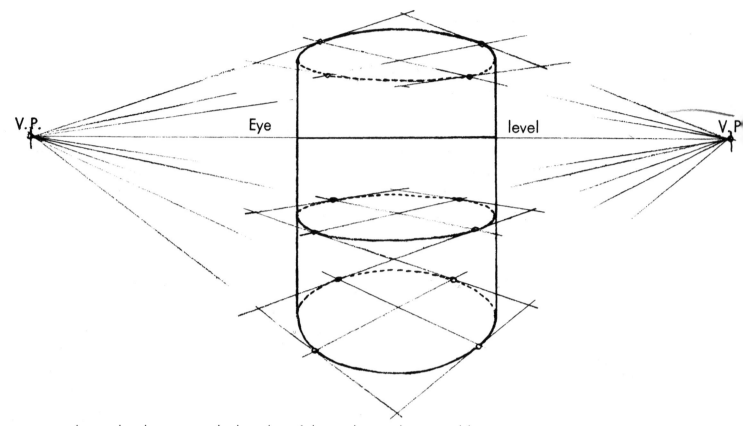

At eye level we see only the edge of the circle as a horizontal line.

Above eye level we see the bottom of the circle.

TRY THIS EXPERIMENT:

Raise a glass vertically and observe how the circular rim changes shape until it becomes a straight line at eye level.

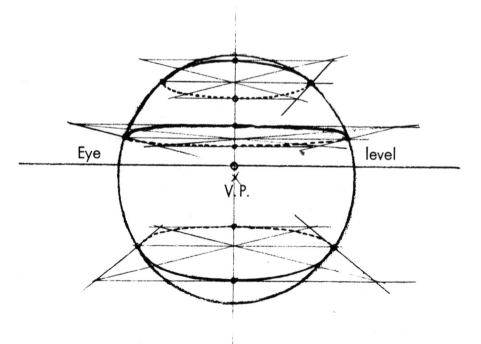

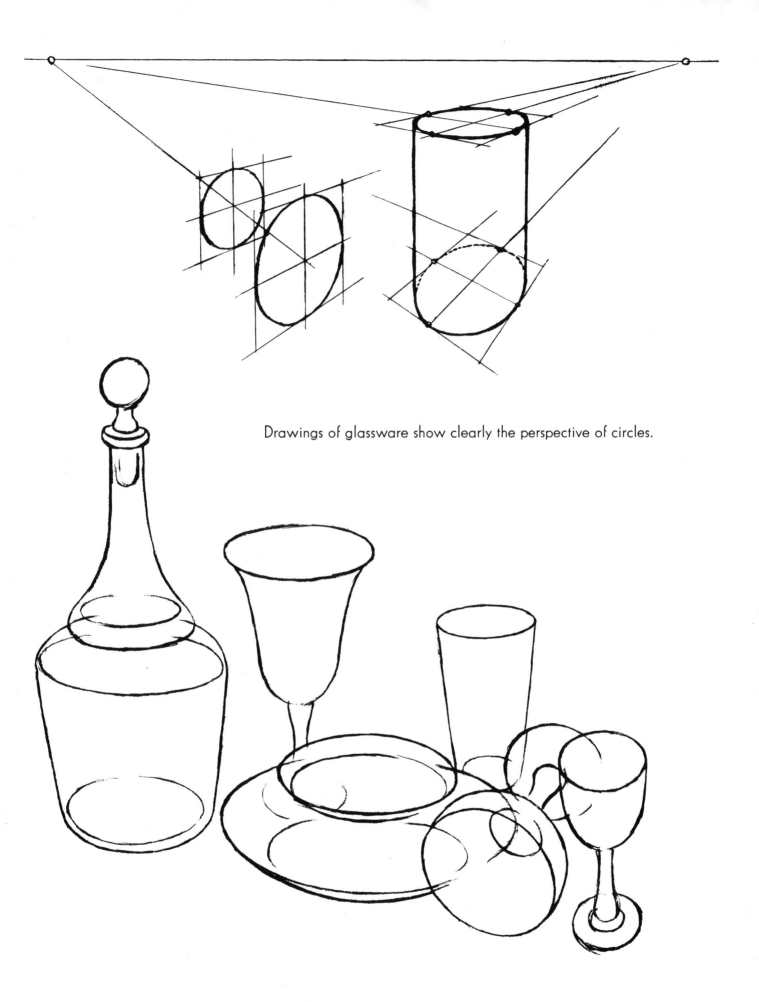

Drawings of glassware show clearly the perspective of circles.

HERE IS THE SOLUTION OF A SIMPLE PROBLEM IN PERSPECTIVE.

The problem is to place a few figures at some distance apart; we want them standing on the spots marked A, B and C.

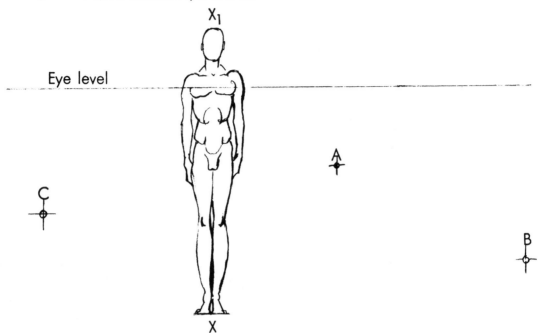

First, we find a Vanishing Point by drawing a projection line from point X, at the foot of the figure, across point A to eye level.

Draw line from X_1 to VP for height of figure.

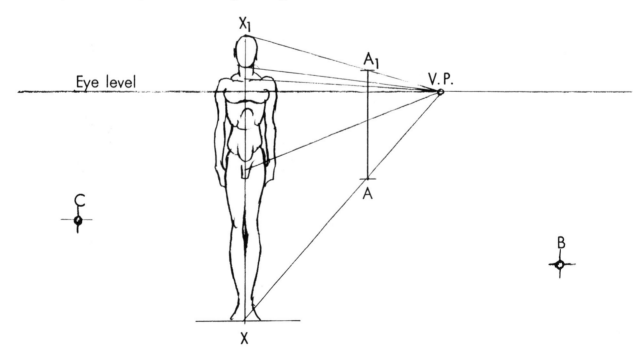

Next, we draw all necessary projection lines to this Vanishing Point. Then a vertical line at point A will give us all proportions for figure A.

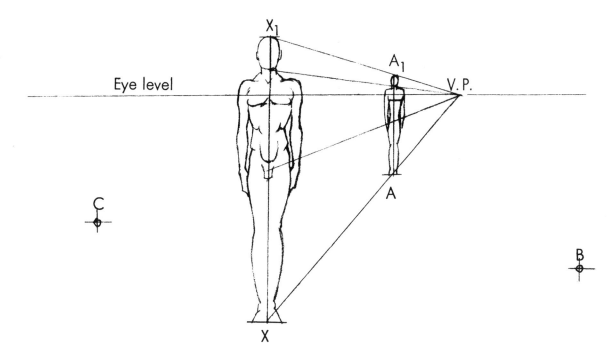

To draw figure on spot B draw horizontal line from B to projection line X — A — VP. From point B_1 draw a vertical line to projection line X_1 — VP. This vertical line B_1—B_2 will give you the height of the figure B—B_3. Proceed in the same manner to draw in figure at spot C.

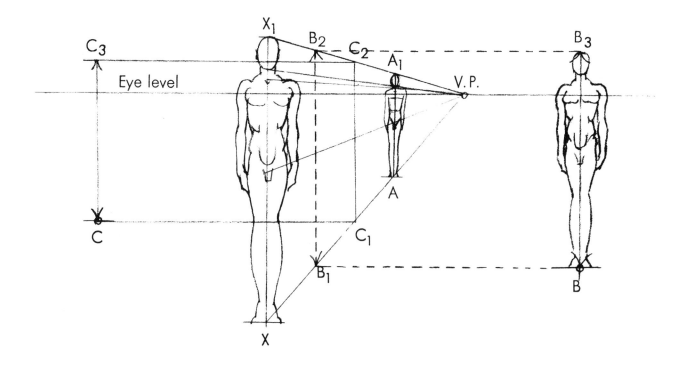

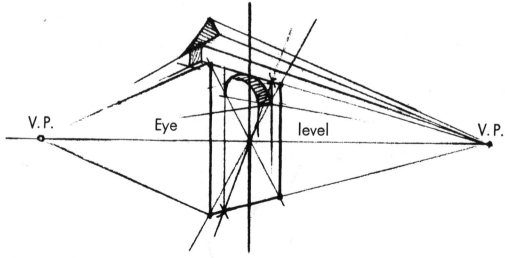

V.P. Eye level V.P.

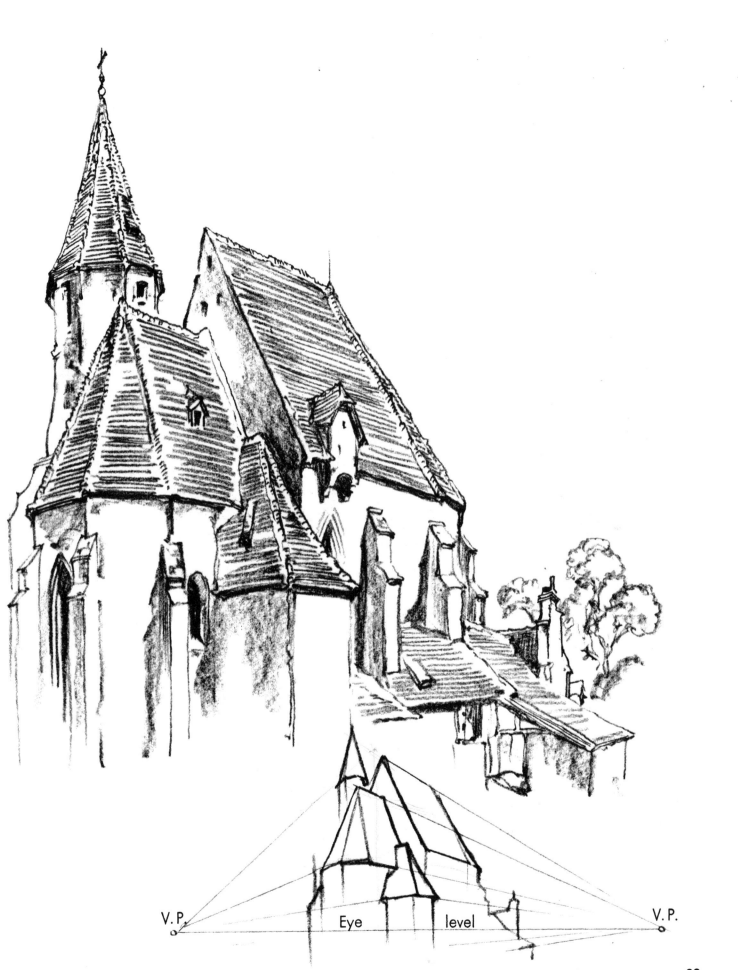

V.P. Eye level V.P.

We measure objects by stretching out our arm and, holding our pencil vertically, indicating the proportionate size with the thumb — like this:

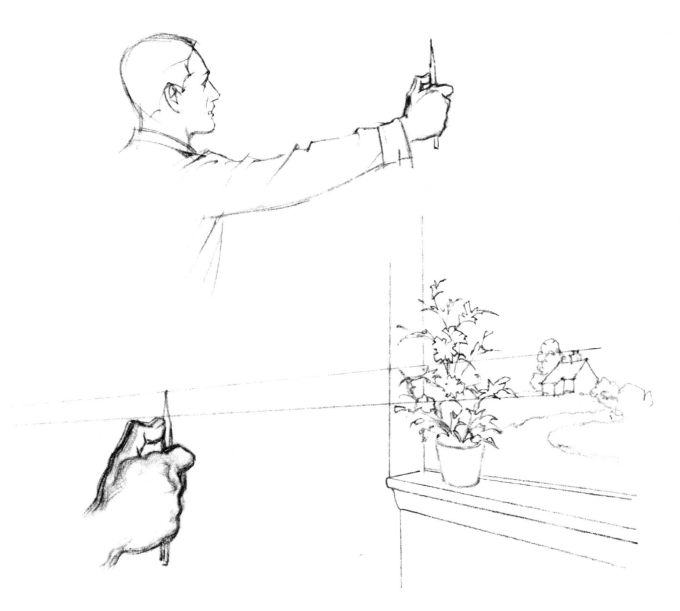

Suppose we stand before an open window. On the window sill is a pot of flowers and, in the distance, a house that we wish to draw.

Whatever the *size* of our drawing the *proportions* will remain the same. In this instance the house will be about one-fifth the size of the flower and the pot, and the flower will be almost four times as high as the pot. All objects and their proportions are measured in the same way.

After you have been drawing for some time you will seldom need to measure in this way. Your eyes will become so adjusted that only occasionally will you need to check by measuring.

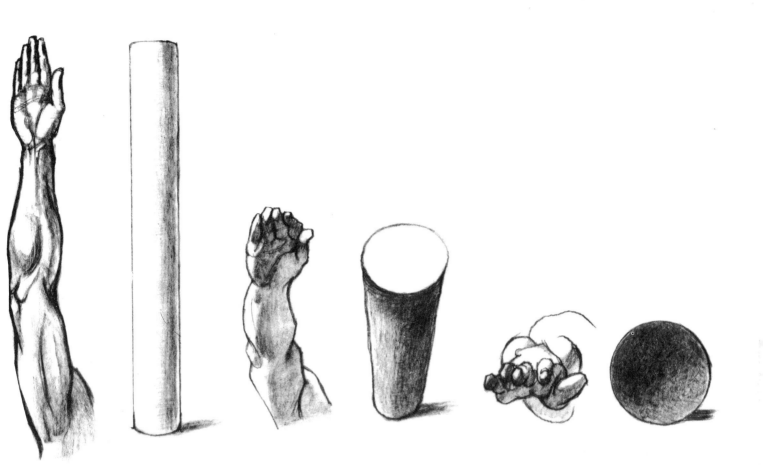

When an object is leaning toward you, the parts nearest you, naturally, seem to be out of proportion, and often hide the parts that are farther back. This visual distortion is called *foreshortening*.

SHADING

The shape of a sphere is a circle like this ⟶

However, the outline shows only its *shape*, shading is necessary to show its *form*.

These spheres are lighted at different angles by a single light source.

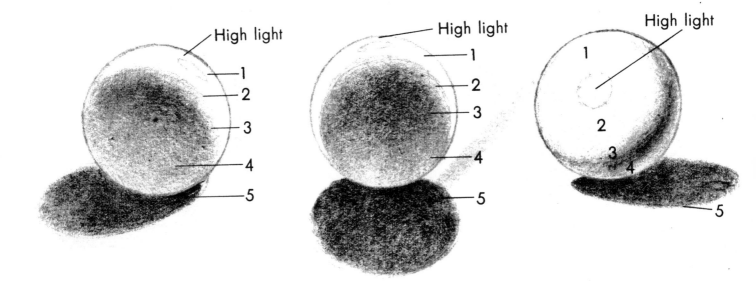

There are, roughly, five distinct tones of shading that characterize a lighted object:

 1. Lighted surface

 2. Shade

 3. Shadow

 4. Reflection

 5. Cast-shadow

The cast-shadow is the darkest shade.

On the lighted surface we usually find a brilliant spot called a *high-light*.

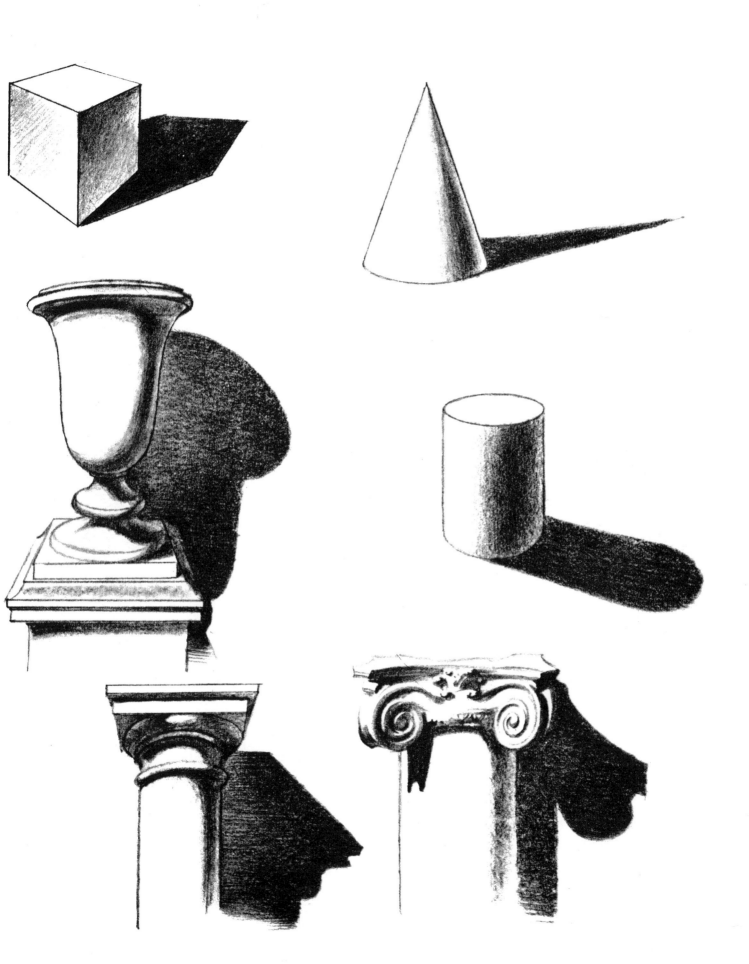

THE HEAD

The human head is oval-shaped like an egg. Viewed from the front it is about one-third longer than at its widest points.

There are various methods of drawing its *ideal* proportions.

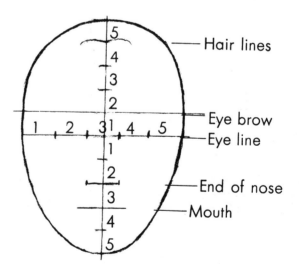

Here is a very simple method:

1. Divide the oval vertically and horizontally into halves.

2. Divide the horizontal into five equal parts.

3. Divide the vertical into ten equal parts — five above and five below the "half-line."

The head viewed from the side is about as wide as it is high.
Two ovals of the same size will give you the approximate shape of the head

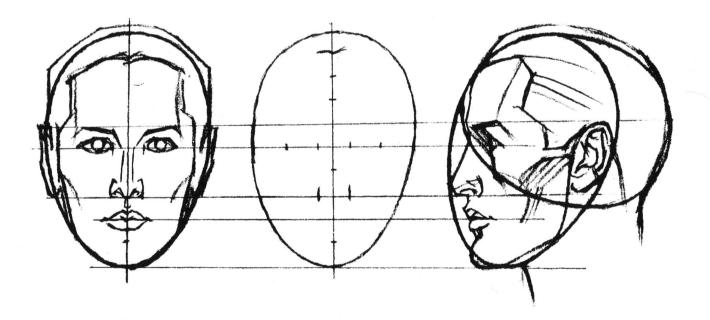

Here are the ovals with the features filled in.

To draw the head intelligently, you should know at least the elementary facts about the skull and the facial muscles.

Here are the names of the different parts of the skull:

1. FRONTAL
2. NASAL
3. ZYGOMATIC (MALAR)
4. MAXILLIAR
5. MANDIBLE
6. SPHENOID
7. TEMPORAL
8. PARIATAL
9. OCCIPITAL

Copy the skull from both views A and B on opposite page — then try to draw them from *memory*.

Here are the names of the facial muscles and their functions:

1. FRONTALIS
 Elevates eyebrow, wrinkles forehead.
2. TEMPORALIS
 Raises mandible (jawbone).
3. ORBICULARIS (oculi)
 Closes eye, stretches skin of forehead.
4. LEVATOR (labii)
 Lifts upper lip upward and outward.
5. ZYGOMATICUS
 Raises upper lip and pulls it outward (laughing).
6. MASSETER
 Raises lower jaw against upper with great force.
7. BUCCINATOR
 Presses lips against teeth.
8. ORBICULARIS (oris)
 Closes lips.
9. DEPRESSOR LABII Inferior
 Draws lower lip down and outward.
10. LEVATOR LABII Inferior
 Raises lower lip and protrudes it forward; also wrinkles chin.

The head in lower right corner shows at points A, B, C and D where the bones of the skull appear just under the skin.

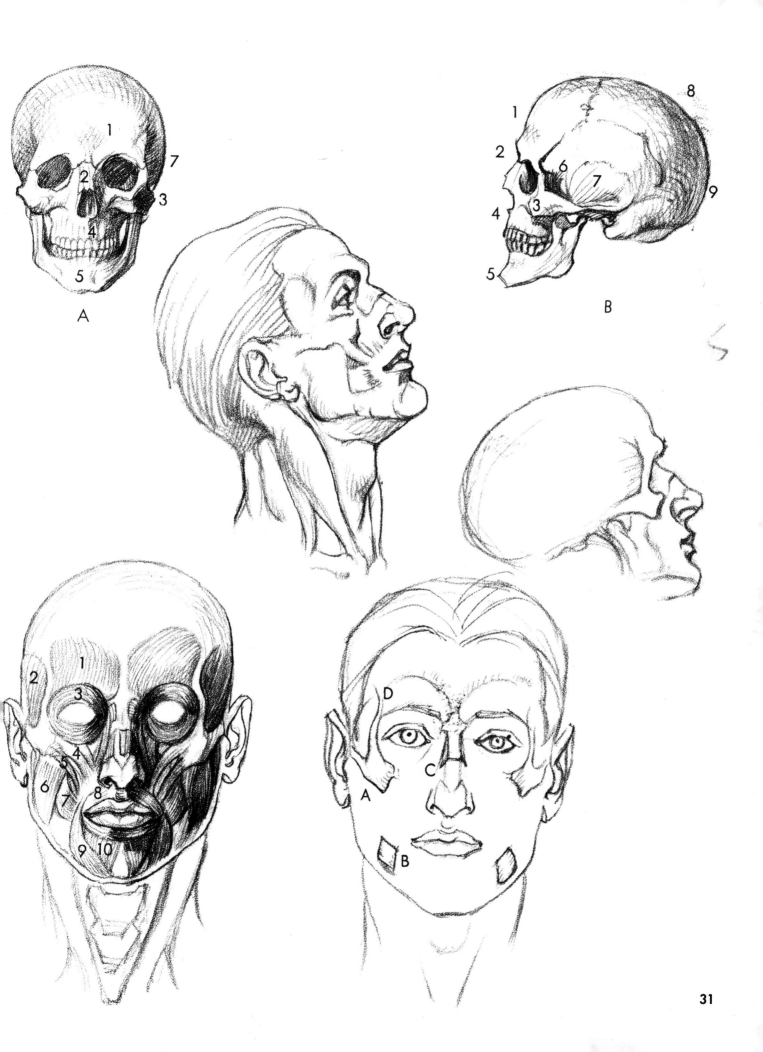

A

B

31

As the head, being spherical in shape, turns and is seen from different angles, our imaginary dividing lines will follow the same laws of perspective as any other circular marking or cross-sections of a sphere.

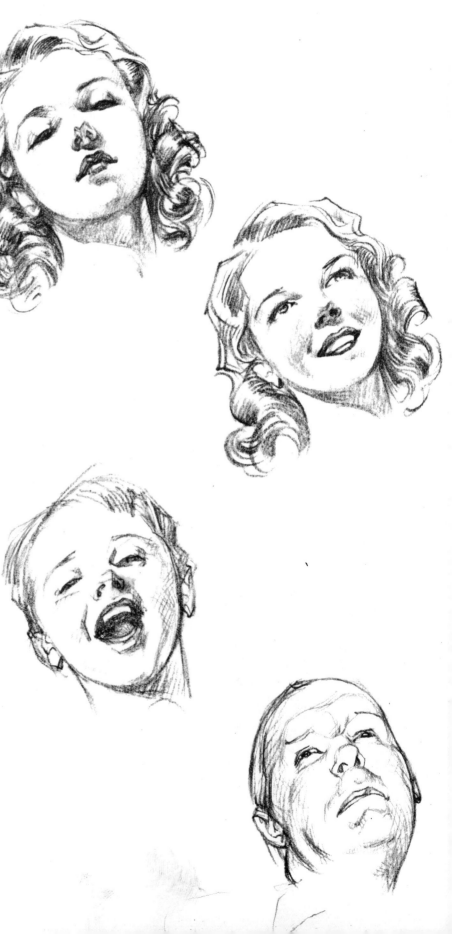

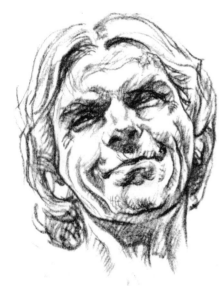

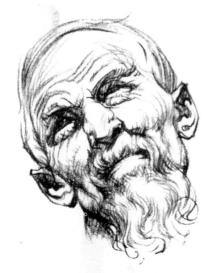

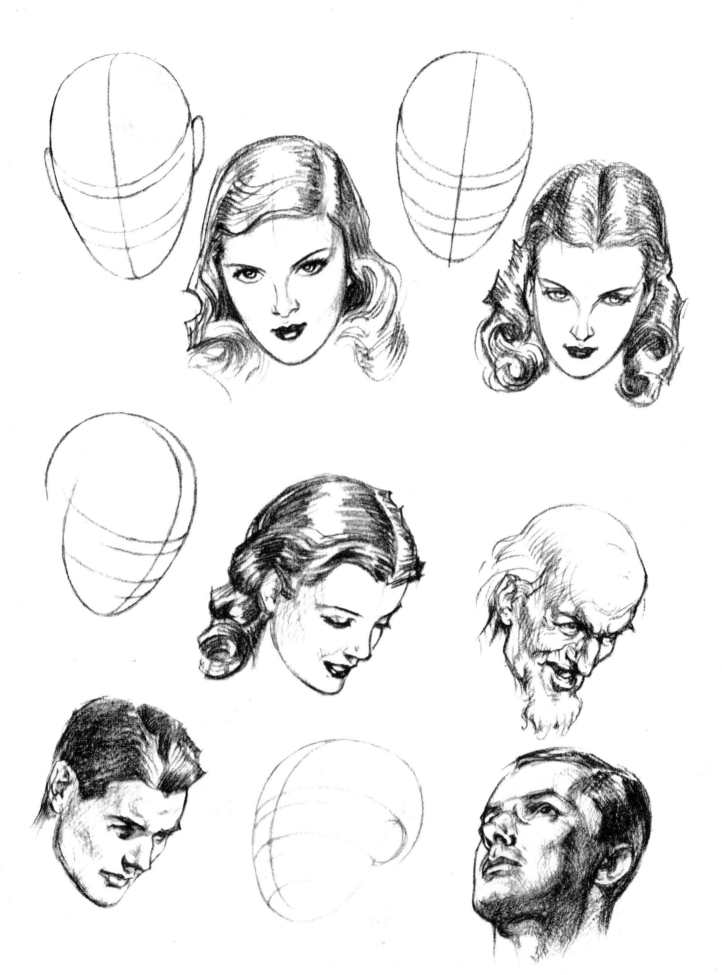

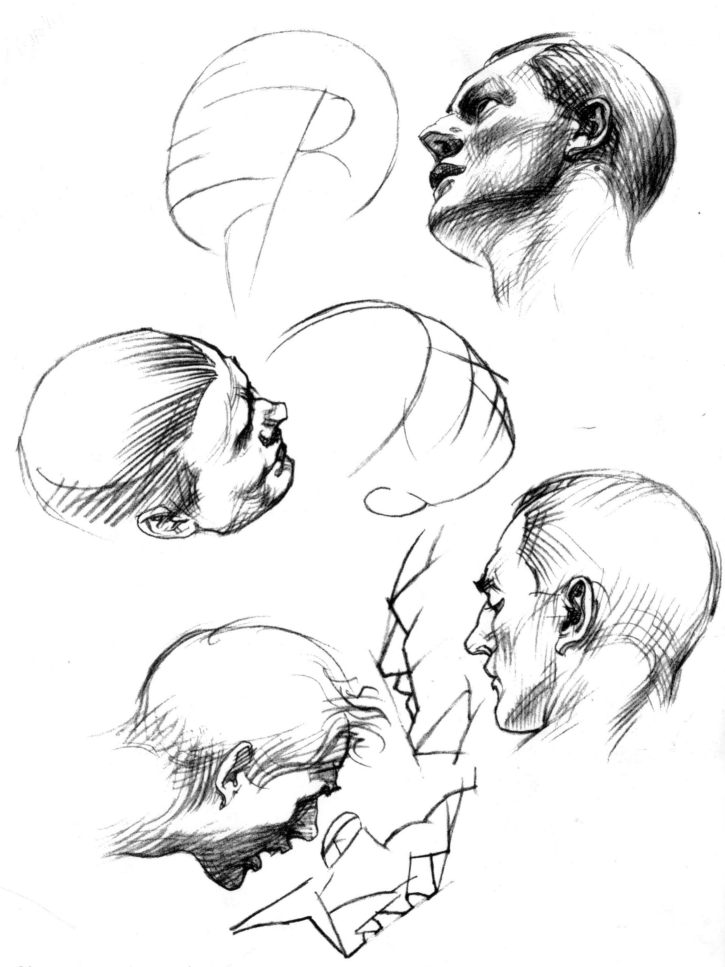

34

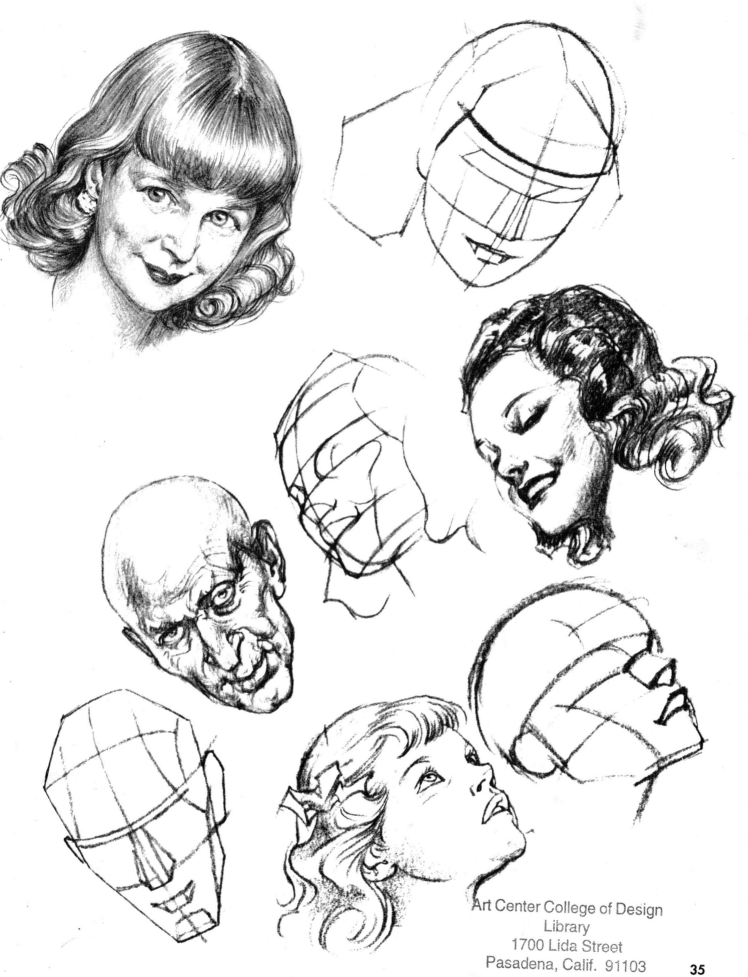

35

PORTRAITURE

Almost everyone who studies drawing would like to draw portraits. A portrait, naturally, should look like the person it represents.

To create a good likeness we must remember that besides getting the correct shape and proportions of the head and features, it is important to study the *character* and *expression* of the sitter.

Before beginning a portrait, study your sitter's face from different angles. Select the angle that will bring out all the desired characteristics.

Lighting is of great importance.

Place your model in a spot that is well lighted from a *single source*. This will give you sharp light and shade, defining clearly the form of each feature.

Diffused light, which does not give any sharp contrast of light and shade, should be avoided by the beginner.

Be sure that both you and your model are comfortable. It is unnecessary to handicap yourself by working in an uncomfortable position.

Walk away from your work frequently; also let the sitter rest at intervals. Talk to him now-and-then to keep him alert and interested.

Be most careful to observe and study the eyes and the mouth.

The mouth is perhaps the most important feature of the face since it expresses the mood and character of the person.

Watch your sitter's mouth as he talks and laughs. Shut your eyes and try to remember and visualize its shape and expression.

Do the same with the eyes. Watch their proportion to the face, their distance from the nose and their distance from each other.

Watch the spot of highlight on the iris.

If you wish the eyes of your portrait to *follow* the onlooker, have the sitter look straight into *your* eyes when you are drawing *his*.

Don't be afraid to emphasize characteristic traits.

Don't *overemphasize* as in making a caricature; but "prettying" will give you bad and inartistic habits.

Check-up on your drawing by holding it before a mirror. You will be surprised how your mistakes will stand out when you see your drawing in reverse.

If you are not satisfied with your drawing and you find that you are unable to correct it, have the courage to discard it and start all over again. Always remember that we learn by our mistakes.

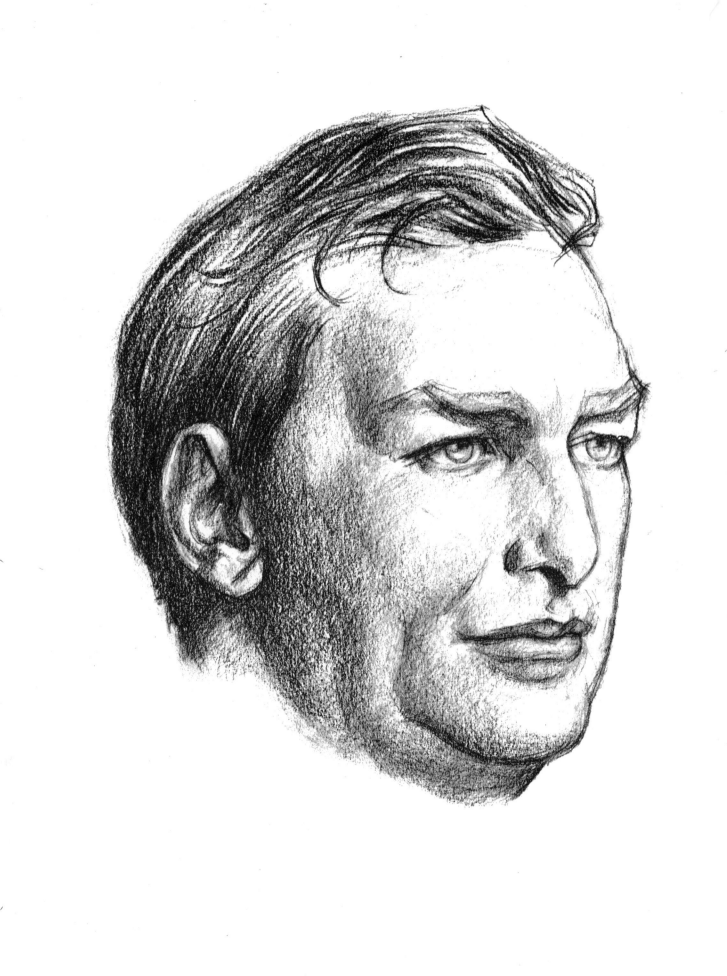

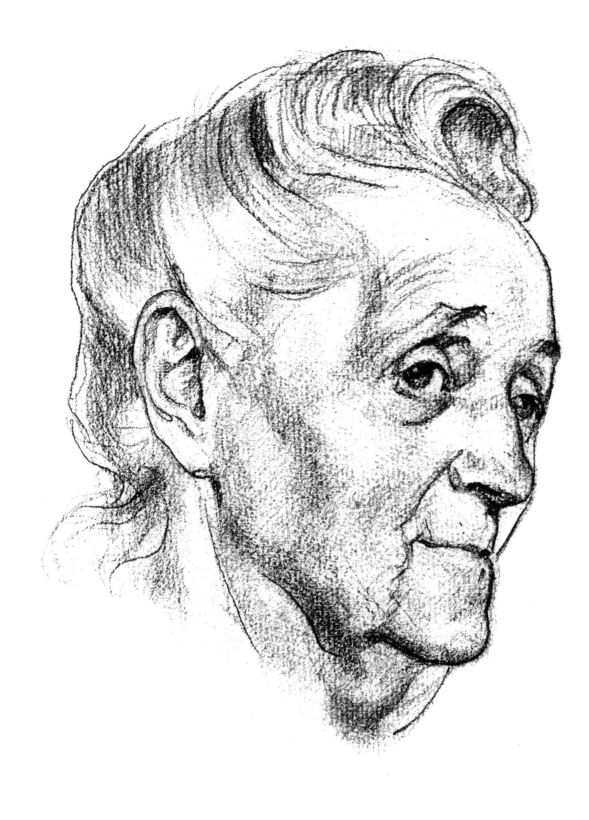

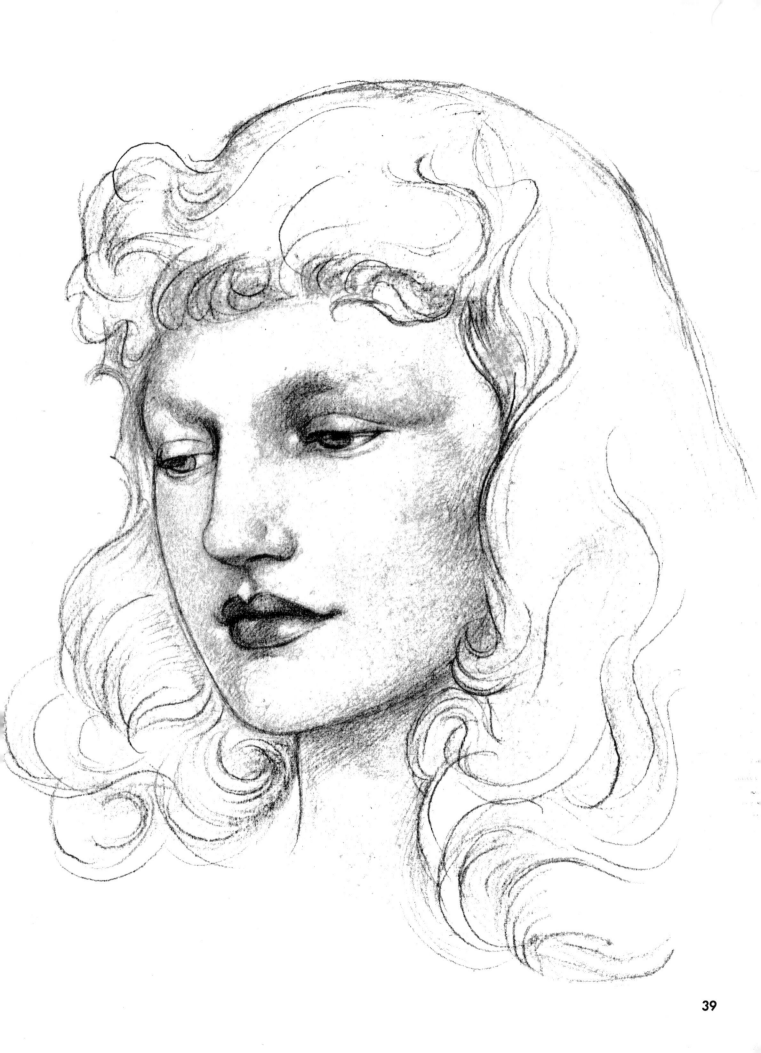

THE EYES

It would be very easy to draw the human eyes if it were not for the eyelids. The eyeballs themselves are simply spherical shapes set into the eye sockets in a way that permits them to revolve in all directions.

The eyes function like a camera and are similarly constructed. The parts of the eye are the eyeball, the lens, the iris, the pupil and the cornea.

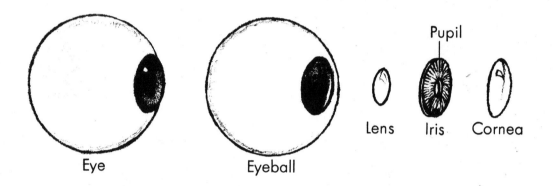

The *iris* is the colored disc of the eye which varies in color in different individuals. It is a circular-shaped diaphragm with a black hole, called the *pupil*, in its center. Behind the pupil is the lens which cannot be seen.

The iris is covered by a transparent cup called the *cornea*. The cornea usually reflects some bright light which makes the eyes brilliant and, at times, even glassy in appearance.

The eyelids act like curtains over the eyes. The upper lid moves up-and-down like a shutter or like the top of a roll-top desk. The lower lid scarcely moves.

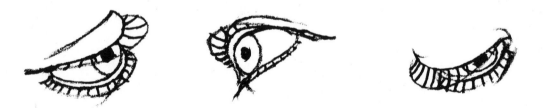

Study the eyelids in their different positions as they open and close, noting their perspective from different angles. Draw their shapes carefully and do not overlook their thickness.

The eyelashes should be drawn with care and not merely as a number of random lines. Remember that the eyelashes grow on the outer edge of the lids and that they radiate from a center.

At the inner corner of each eye is the triangular-shaped tear gland.

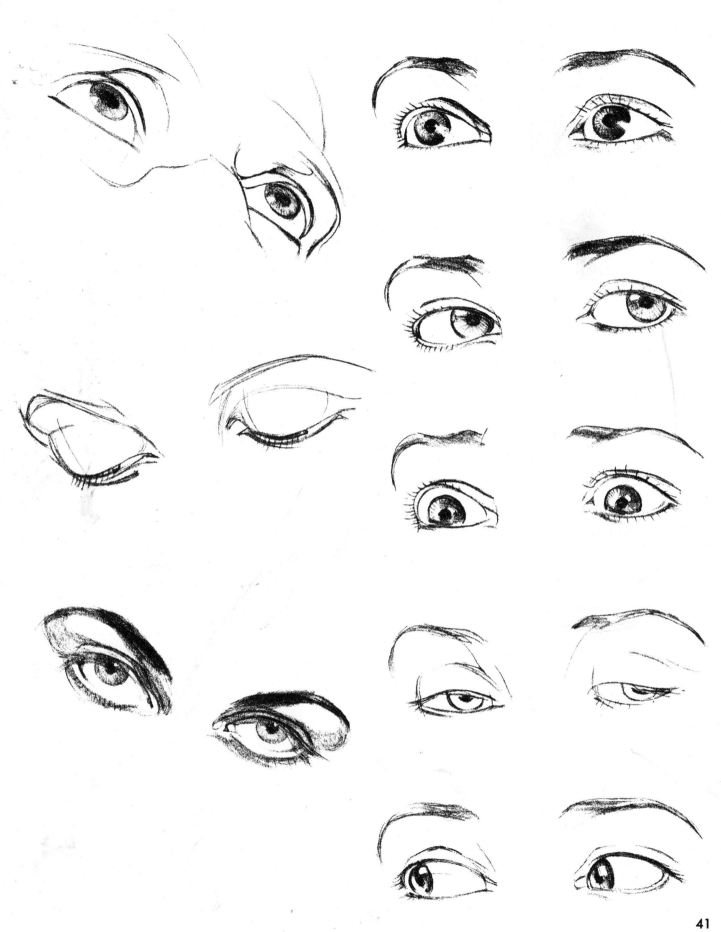

THE MOUTH

To draw the human mouth, when at rest without any particular expression, is simple enough and should not present any special difficulty. It is necessary only to be careful about its proportions and the perspective of its curved surfaces.

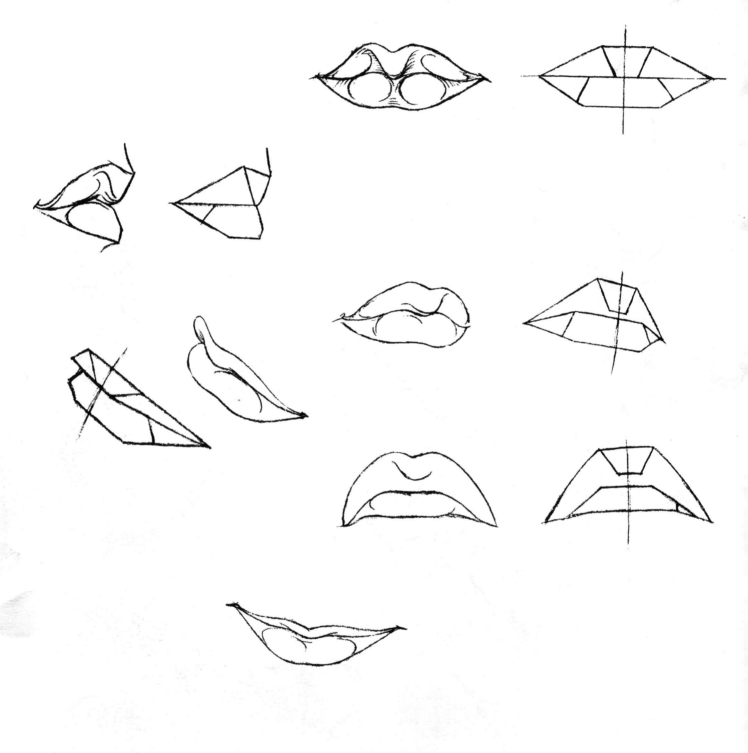

The mouth is extremely mobile and is seldom lacking in some expression. It will smile or pout, express grimness, anger, pain, pleasure, laughter, shouting, speaking, whistling and so on.

The best way to study the mouth and draw it with such diverse expressions is to look into a mirror and be your own model.

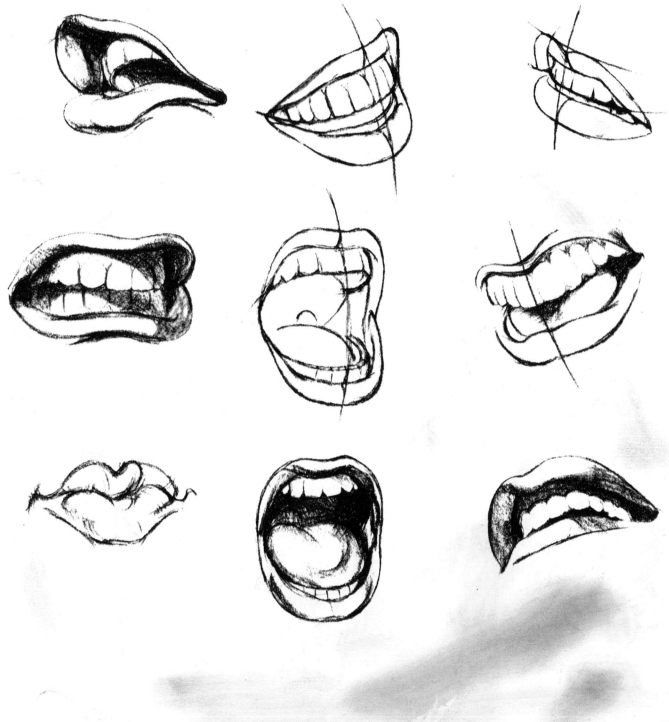

THE EARS

When drawing the human ear be careful about placing it on the right spot and at the correct angle. The ear is placed at the outer edge of the jawbone and the angle runs parallel with the length of the nose. A well-drawn ear is a thing of beauty. The curved forms should be very carefully observed and followed. Many a fine study of the human head is spoiled by slipshod drawing of the ear.

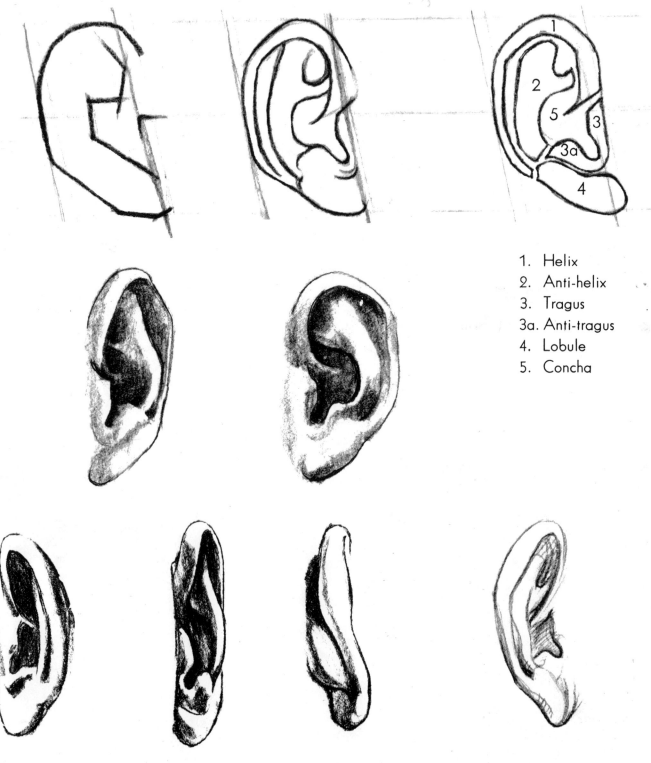

1. Helix
2. Anti-helix
3. Tragus
3a. Anti-tragus
4. Lobule
5. Concha

THE NOSE

Noses are of various shapes and sizes. The shape and proportions of the nose are extremely important characteristics of every face; so if you want to draw a good likeness, take great pains in drawing the nose accurately.

 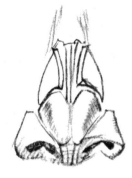 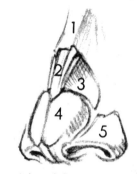

1. Nasal Bone
2, 3, 4 and 5 Cartilages

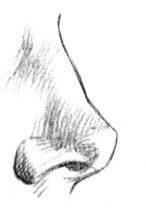 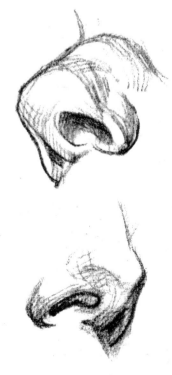 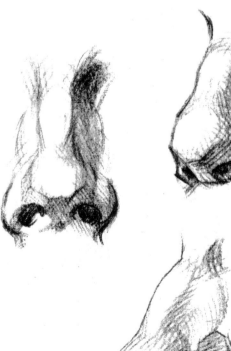

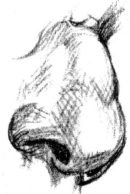

THE HANDS

The hand, after the head, is of primary interest to the artist. Copy these ana-
tomical charts repeatedly until you become thoroughly familiar with all the
minute details of the hand — then draw it from memory:

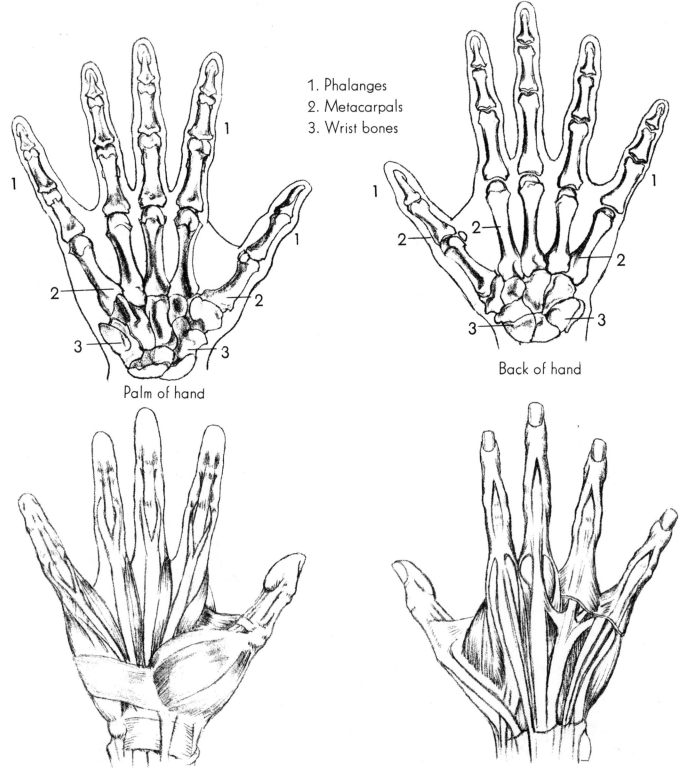

1. Phalanges
2. Metacarpals
3. Wrist bones

Palm of hand

Back of hand

This is how the hand works.

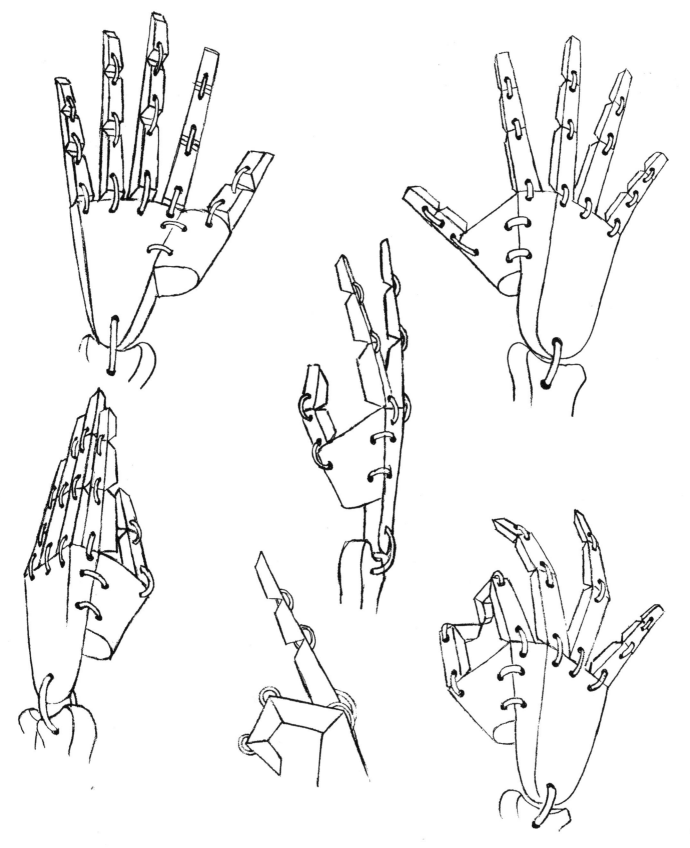

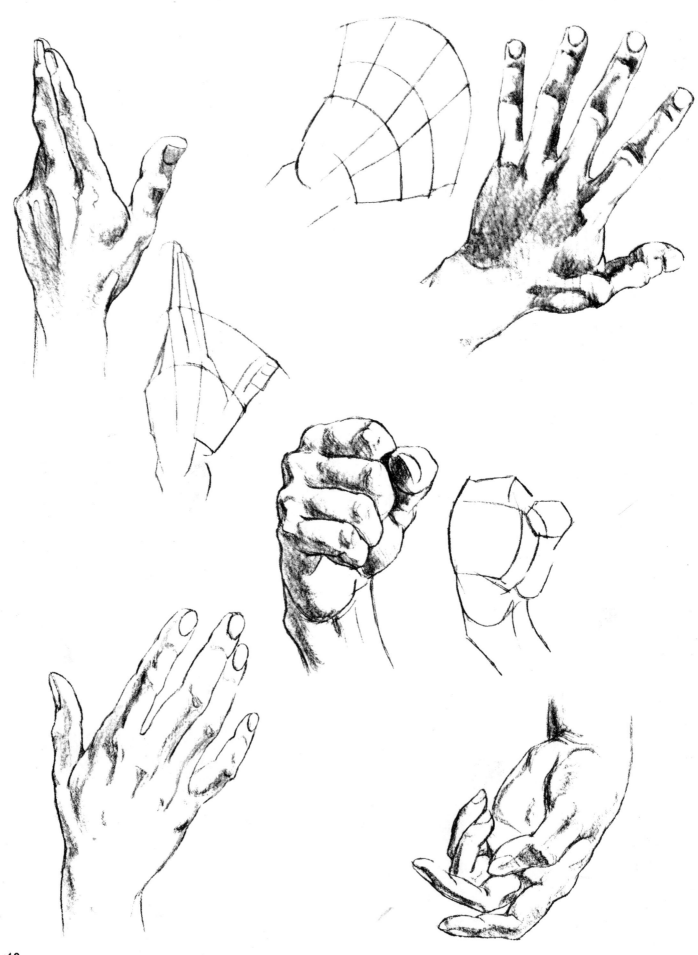

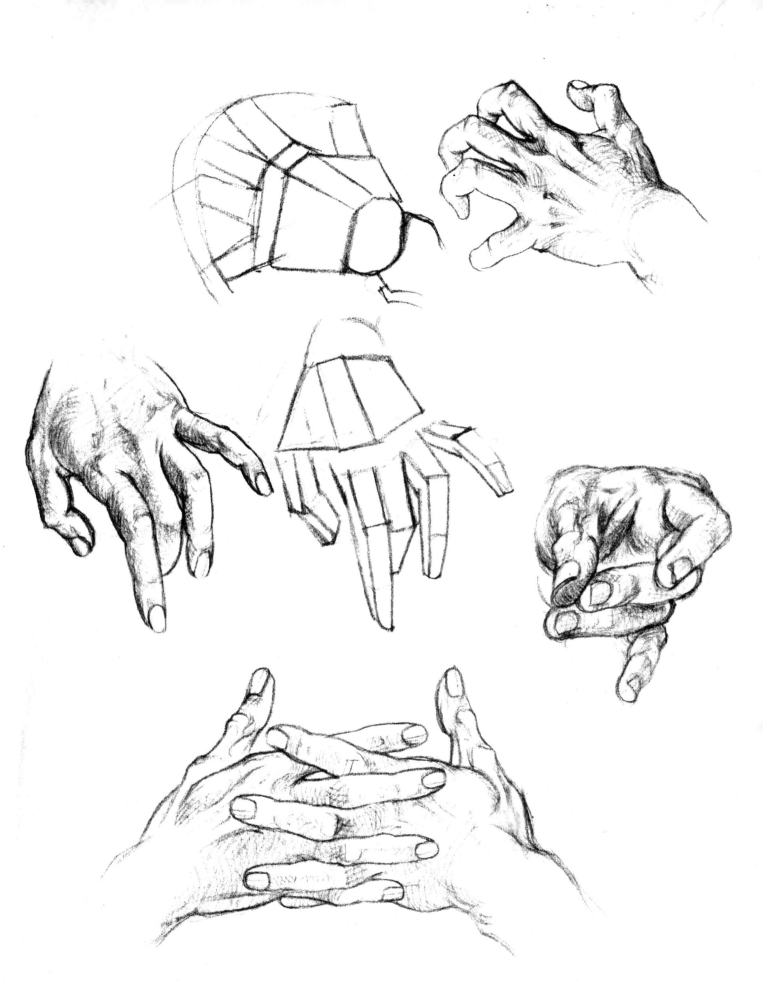

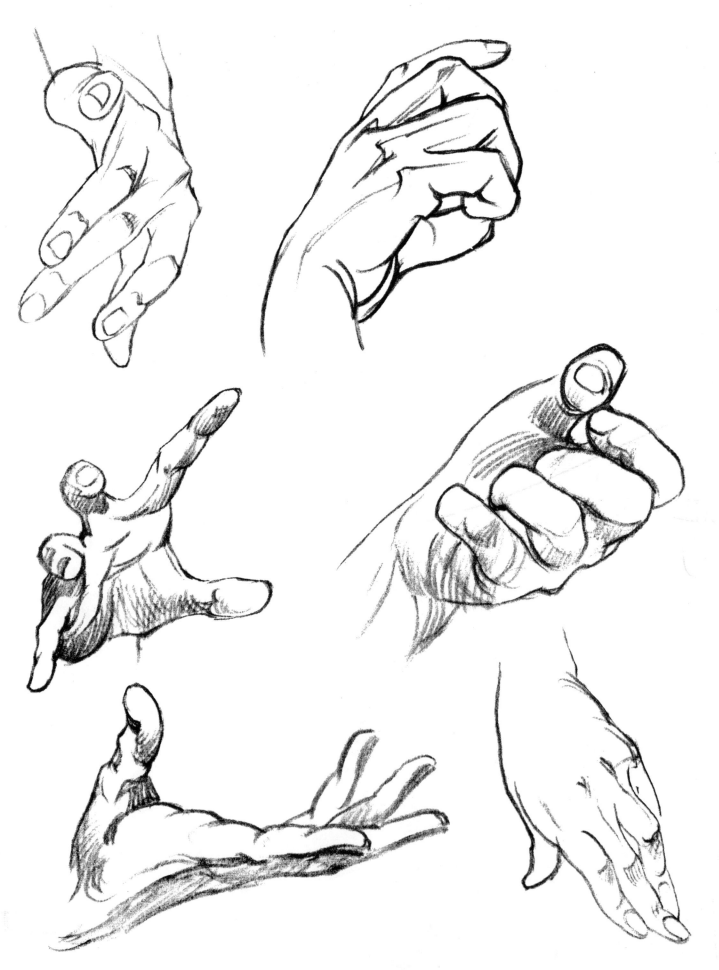

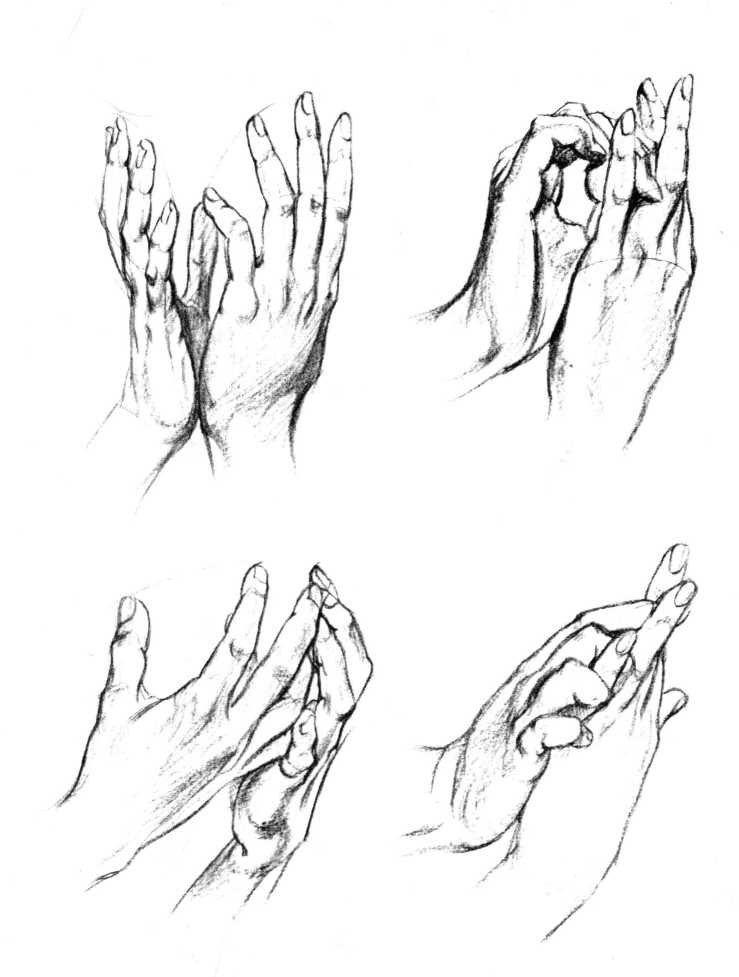

THE FEET

The muscles, bones, and tendons of the foot are comparatively small.

The foot is constructed in a series of arches.

These arches form a remarkable "engineering" structure, making it possible for the feet to support the weight of the entire body.

When drawing a foot, first "block out" its general shape.

Within this outline "block out" the forms of the sections cf the foot, making sure they are correct in proportion and angle. Be especially careful about the proportions of the toes — also the position of the ankles.

THE BONES OF THE FOOT

1. Os Calcis
2. Astragalus
3. The bones of the Tarsus
4. Metatarsal Bones
5. The Phalanges of the Toes.

MUSCLES

The muscles of the sole, the *abductors*, bend the toes.
The muscles of the instep, the *extensors*, stretch the toes.

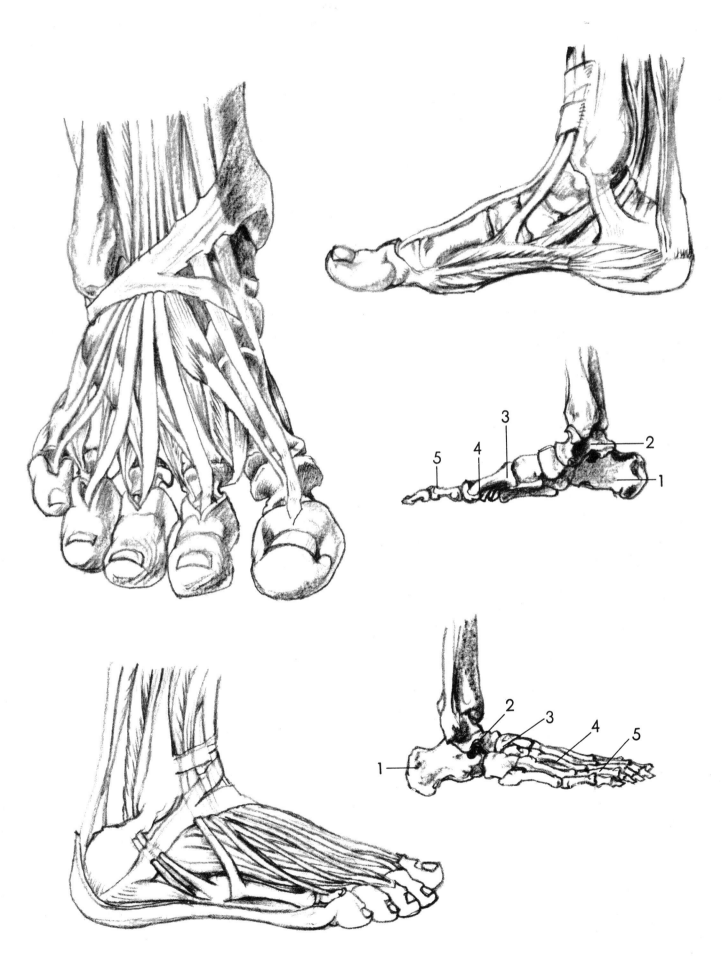

3
4
5
2
1

2
3
4
5
1

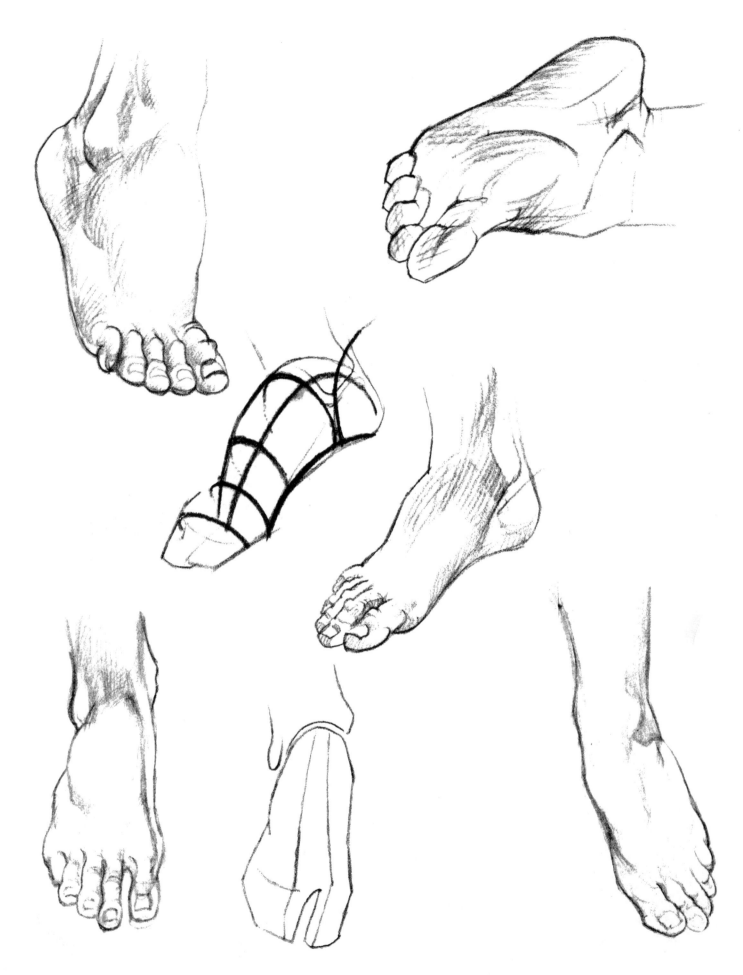

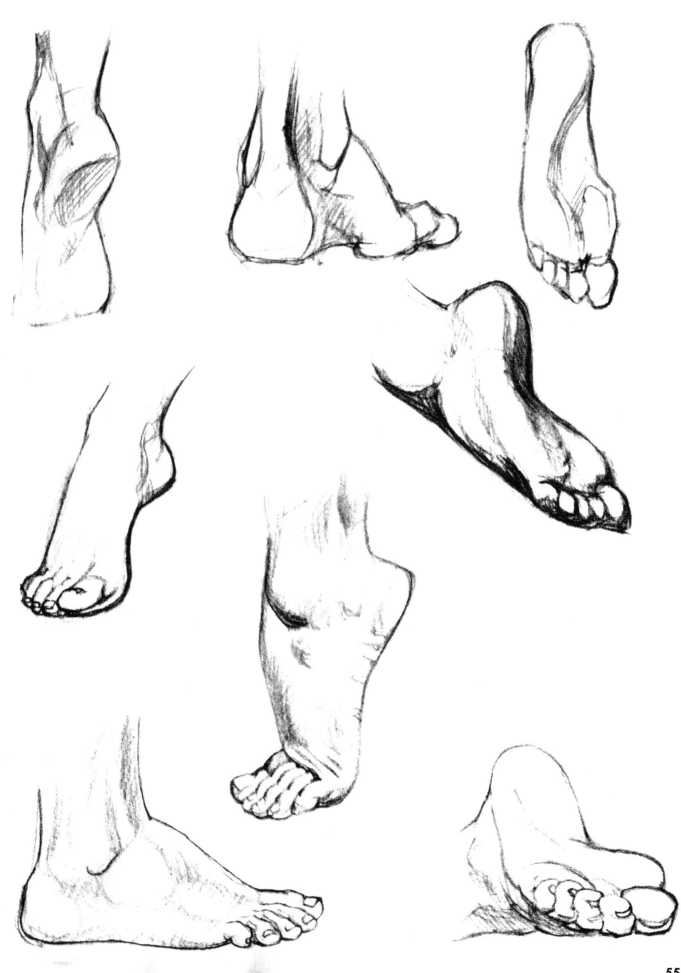

THE FIGURE

Here are the proportions of the male and female adult figures. The actual proportions are nearer seven and one half headlengths, but here we use eight headlengths, because it is easier to divide eight into equal parts. Furthermore, this elongates the figure and makes it more appealing. We put the center division (see chart) at the crotch, but in real life it usually comes above the crotch.

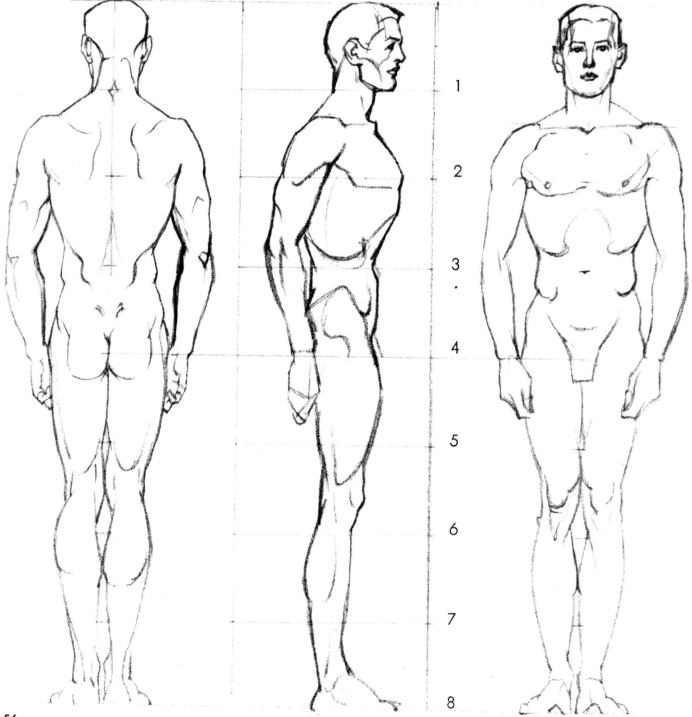

1

2

3
·

4

5

6

7

8

This division, and the proportion of eight headlengths, makes the figure longer-legged and more ideal.

However, when you draw from life, I would advise you to keep as close as possible to actual measurements.

Study the charts and you will find that the second headlength goes through the nipple of the breast, the third through the waistline, the fourth through the crotch, and the sixth goes below the knees.

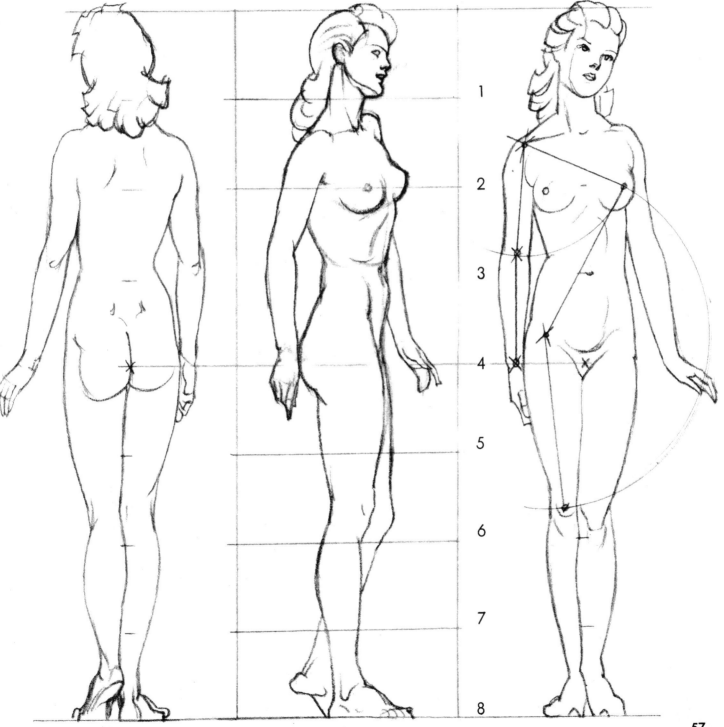

1

2

3

4

5

6

7

8

PROPORTIONATE HEIGHT OF FIGURES IN DIFFERENT POSITIONS.

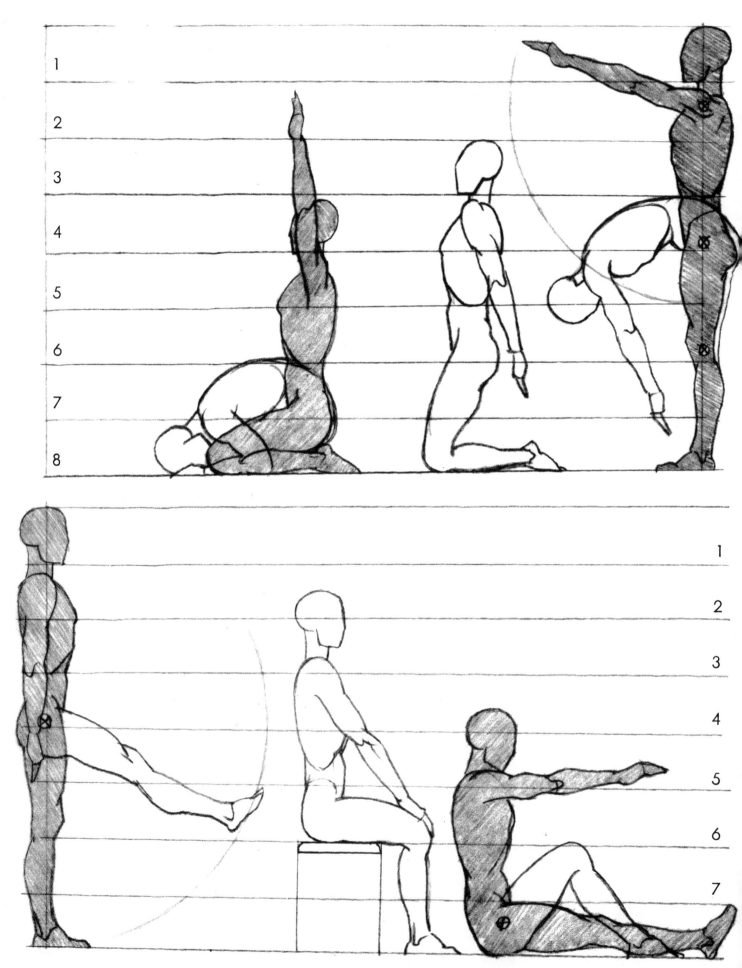

The proportions of a child's body vary according to age.

An infant will measure scarcely three headlengths. Its head is large, the torso is long, and the arms and legs are very short.

These proportions change as the child grows. Looking at the chart you will notice how the body, the legs and the arms get longer as the child grows older. The head grows very slowly. The older the child, the closer its proportions approximate those of an adult.

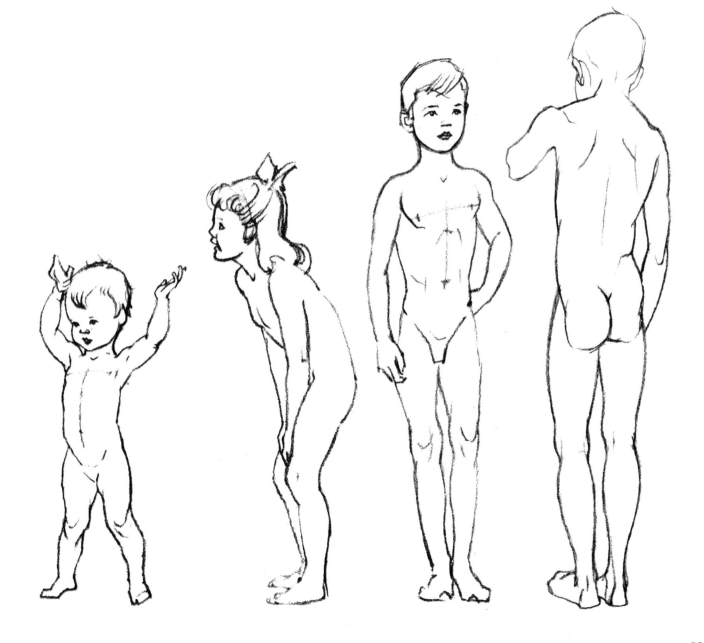

BONES OF THE SKELETON
FRONT VIEW

1. Skull
2. Clavicle
3. Humerus
4. Radius
5. Ulna
6. Carpus

7. Metacarpals
8. Phalanges
9. Sternum
10. Ribs
11. Pelvis
12. Femur

13. Patella
14. Tibia
15. Fibula
16. Tarsals
17. Metatarsals
18. Phalanges

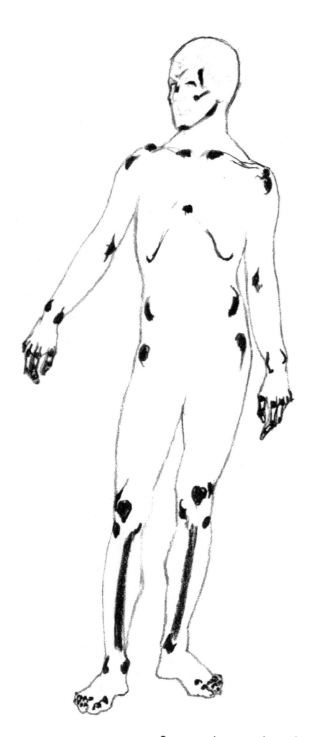
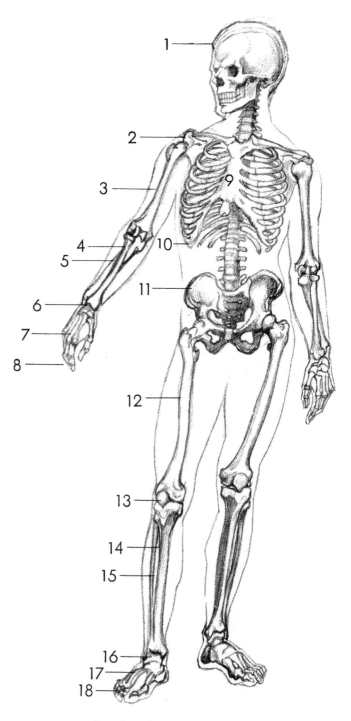

Spots indicate where bones appear just under the skin.

BONES OF THE SKELETON
BACK VIEW

1. Skull
3. Humerus
4. Radius
5. Ulna
6. Carpus
7. Metacarpals

8. Phalanges
10. Ribs
11. Pelvis
12. Femur
14. Tibia
15. Fibula

16. Tarsals
17. Metatarsals
18. Phalanges
19. Scapula
20. Vertical column
21. Sacrum

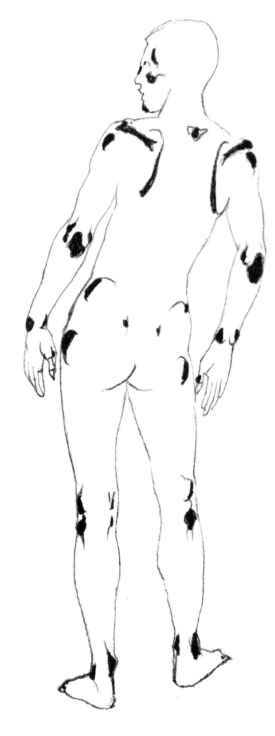

Spots indicate where bones appear just under the skin.

FRONTAL MUSCLES OF THE ARM

1. DELTOIDEUS
 Front Section pulls and rotates arm inward.
 Back Section lifts and rotates arm outward.

2. BICEPS BRACHII
 Turns, brings arm forward, bends and turns forearm.

3. TRICEPS BRACHII
 Extends forearm, brings arm forward at shoulder joint.

4. BRACHIALIS
 Bends forearm.

5. SUPINATOR LONGUS
 Turns hand, palm outward.

6. EXTENSOR CARPI RADIALIS
 Extends and turns hand, bends forearm.

7. PRONATOR TERES
 Turns forearm inward, bends elbow joint.

8. EXTENSOR DIGITORUM
 Extends fingers and wrist.

9. FLEXOR CARPI RADIALIS
 Flexes wrist.

10. FLEXOR CARPI ULNARIS
 Bends and brings wrist forward.

11. FLEXOR POLICIS LONGUS
 Bends thumb.

FRONTAL MUSCLES OF THE TORSO

12. PECTORALIS GROUP
 Brings forward and rotates arm inward, also pulls shoulder blade forward or ribs upward.

13. LATISSIMUS DORSI
 Brings arm forward, extends and rotates arm inward.

14. SERRATUS ANTERIOR
 Draws shoulderblade forward, rotates lower point of shoulder blade outward.

15. RECTUS ABDOMINIS
 Draws chest downward, pelvis up.

16. LINEA ALBA
 Divides Rectus Abdominis vertically.

17. OBLIQUUS
 Compresses abdomen, pulls chest forward.

18. INGUINAL LIGAMENT

FRONTAL MUSCLES OF THE LEG

19. PSOAS ILIACUS
 Bends thigh, rotates and pulls hip-joint inward.

20. PECTINEUS
 Brings thigh forward.

21. ADDUCTOR LONGUS
 Brings forward and rotates thigh.

22. GRACIALIS
 Bends knee, lifts thigh, rotates leg inward.

23. SARTORIUS
 Rotates thigh outward, flexes thigh and leg.

24. RECTUS FEMORIS
 Stretches leg at knee and body on hips.

25. VASTUS MEDIALIS
 Works same as Rectus Femoris.

26. VASTUS LATERALIS
 Works same as 24 and 25.

27. PATELLAR LIGAMENT

28. GASTROCNEMIUS (Calf)
 Bends knee, extends, lifts and turns down foot.

20. SOLEUS
 Stretches, lifts and turns down foot.

30. EXTENSOR DIGITORUM LONGUS
 Flexes ankle, stretches the four smaller toes.

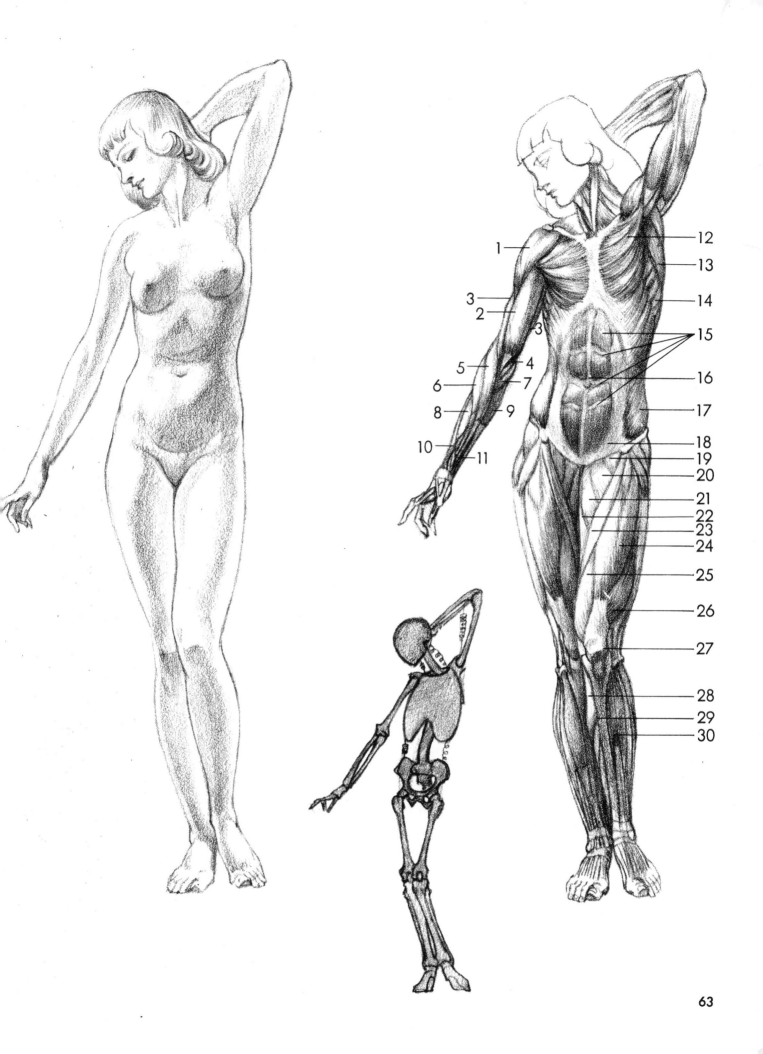

1

12

13

3
2

3

14

15

5
6

4
7

16

8

9

17

10

18
19
20
21
22
23
24

11

25

26

27

28
29
30

SIDE VIEW OF MUSCLES OF ARM

1. Deltoideus
2. Biceps Brachii
3. Triceps Brachii
4. Brachialis
5. Supinator Longus
6. Extensor carpi radialis
7. Pronator teres
9. Flexor carpi radialis

SIDE VIEW OF MUSCLES OF TORSO

12. Pectoralis
13. Latissimus Dorsi
14. Serratus Anterior
15. Rectus Abdominis
17. Obliquus
18. Inguinal Ligament

SIDE VIEW OF MUSCLES OF LEG

31. Gluteus medius: Draws thigh aside and rotates it inward
32. Gluteus maximus: Stretches thigh, draws it forward and rotates it outward
33. Tensor fasiae latae: Stiffens outer side of thigh and rotates it inward
24. Rectus Femoris
26. Vastus Lateralis
34. Biceps Femoris: Bends knee-joint, stretches thigh and rotates leg outward when knee is bent
28. Gastrocnemius
35. Peroneus Longus: Supports arch of foot, stretches, turns and draws foot outward
29. Soleus
30. Extensor Digitorum Longus

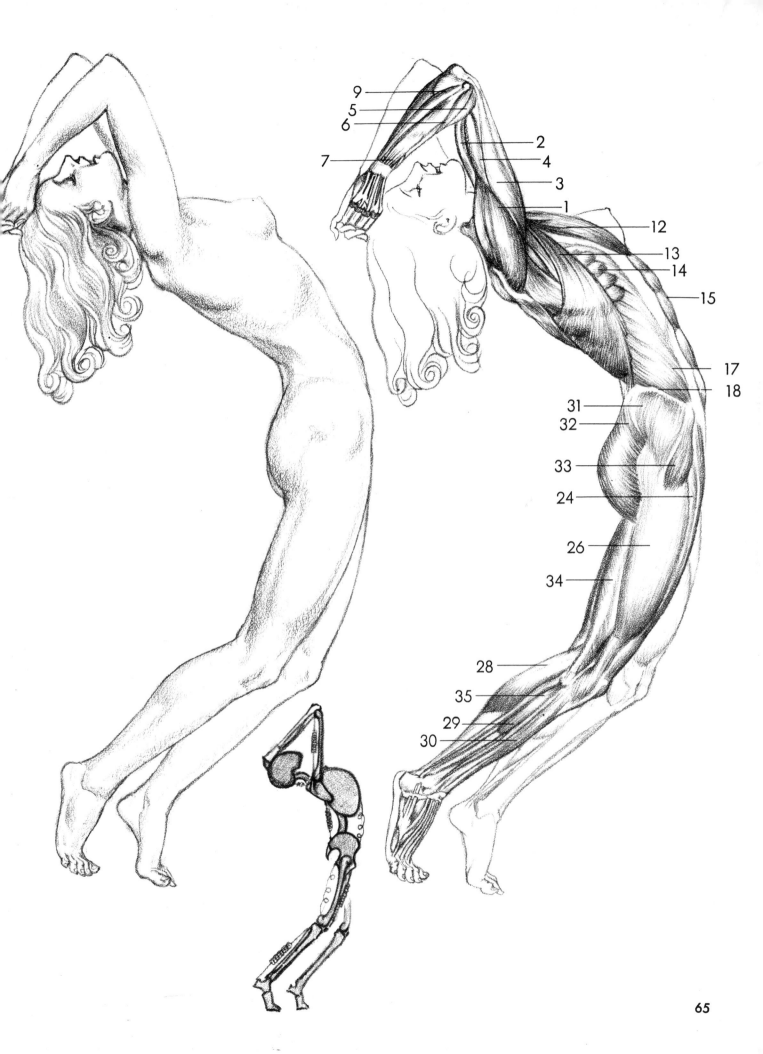

9
5
6
7

2
4
3
1
12
13
14
15
17
18
31
32
33
24
26
34
28
35
29
30

MUSCLES OF THE BACK

37. Trapezius: Turns lower angle of shoulder blade outward and foreward, draws the shoulderblades toward each other, elevates outward top of shoulder blade, extends the head

38. Infraspinatus: Rotates arm outward

39. Teres major: Rotates arm inward

40. Rhomboideus: Elevates shoulder, rotates lower part of shoulder blade inward, draws shoulder blades toward each other

13. Latissimus Dorsi

31. Gluteus medius

32. Gluteus maximus

21. Adductor longus

26. Vastus Lateralis

34. Biceps Femoris

28. Gastrocnemius

35. Peroneus Longus

41. Achilles tendon

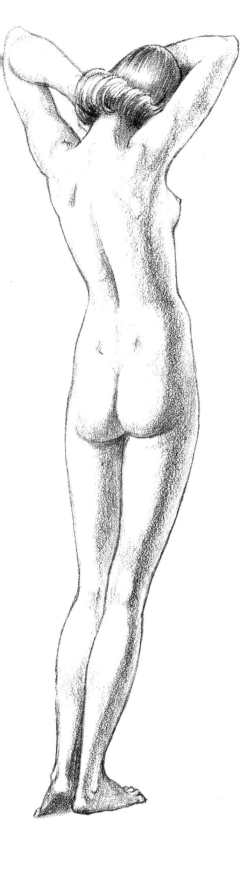
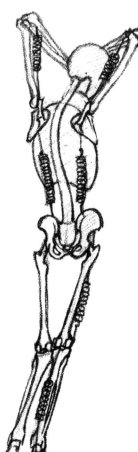
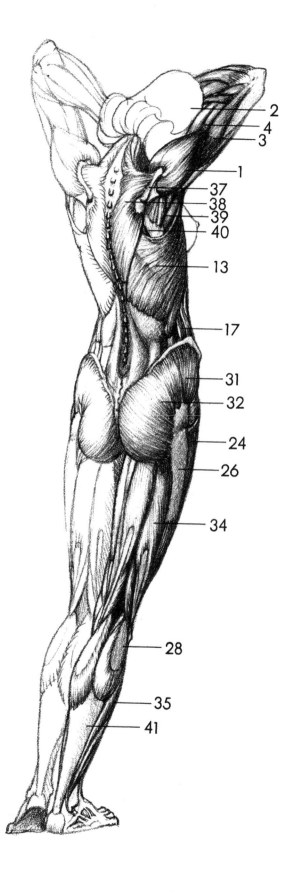

2
4
3
1
37
38
39
40
13
17
31
32
24
26
34
28
35
41

Without muscles our bodies could not move. We could not walk, bend, kick, or even smile.

Expanded Contracted

A muscle works like a spring. You can see this action very plainly when you expand and contract your biceps.

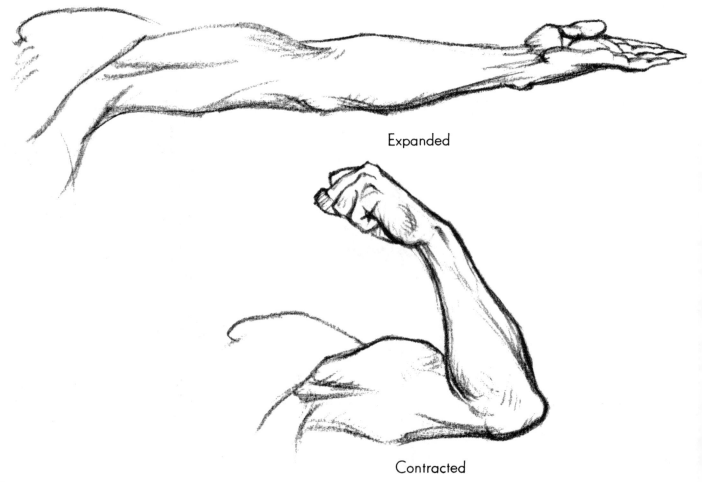

Expanded

Contracted

The human body must be supported, and kept in balance, otherwise it will topple over. Be sure that the weight is properly distributed. The line of gravitation goes through the supporting feet of the dark figures on the chart, while the light figures lean too far out for safety.

When drawing a figure, start with a vertical line so that the figure does not seem to be floating in the air or toppling over.

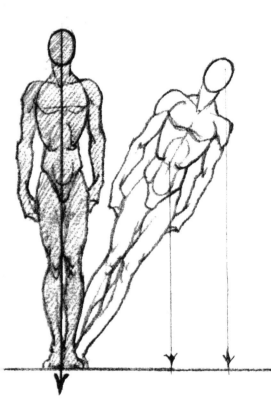

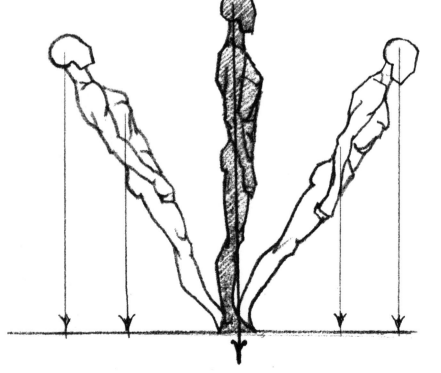

BALANCE AND MOTION

Figure 1 represents a rigid human body. The three heavy sections denote the head, the chest and the pelvic section. The smaller sections denote the neck, the waistline and the leg-joints. However, the human figure is seldom, if ever, as motionless as in Fig. 1.

In Figure 2 we see that when the head tilts one way the shoulder line immediately tilts in the opposite direction, and the pelvic line tilts opposite to that of the shoulder line. This is an unfailing rule of perfect balance.

This countermovement holds true in every action, and in every direction. For instance, in walking or running, when the right foot goes forward, it is the left arm that goes forward at the same time, and *vice versa* (Figs. 4, 5 and 6).

Keep strictly to this principle if you want true movement, otherwise your figures will be static and *posey*.

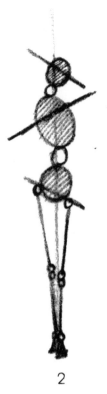

2

1

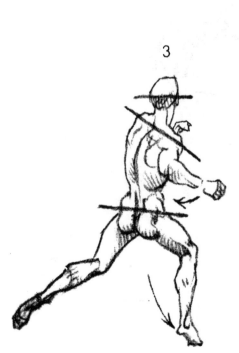

3

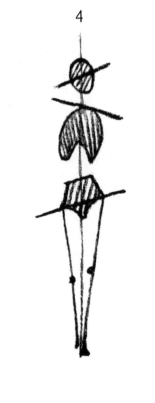

4

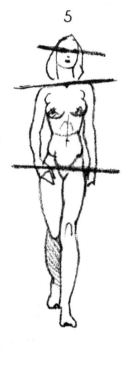

5

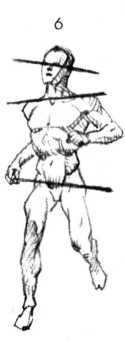

6

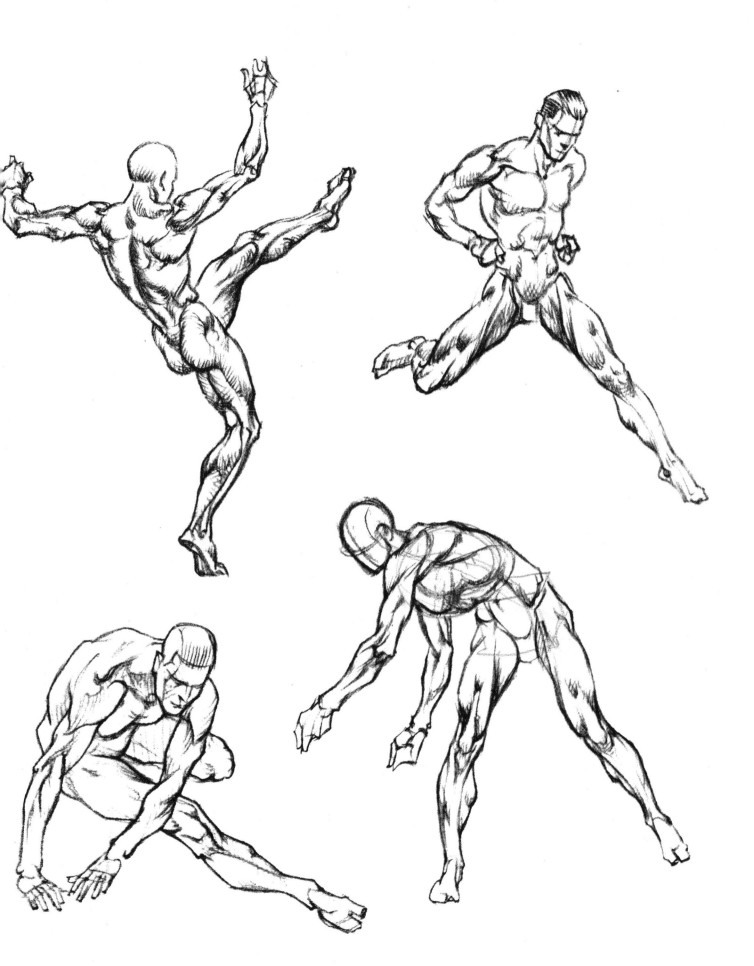

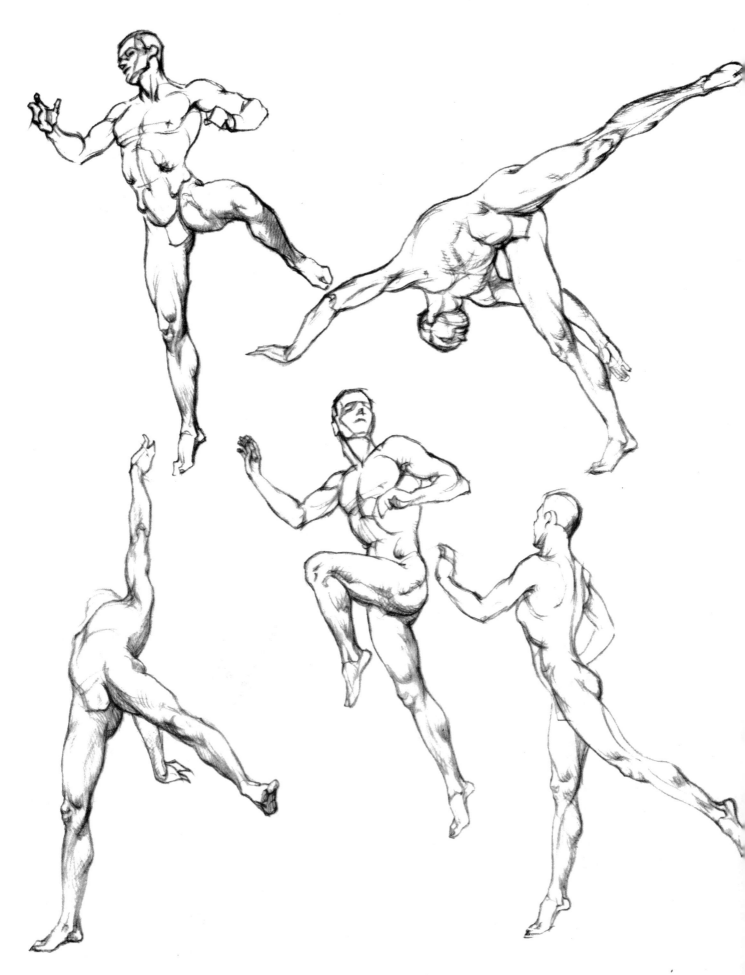

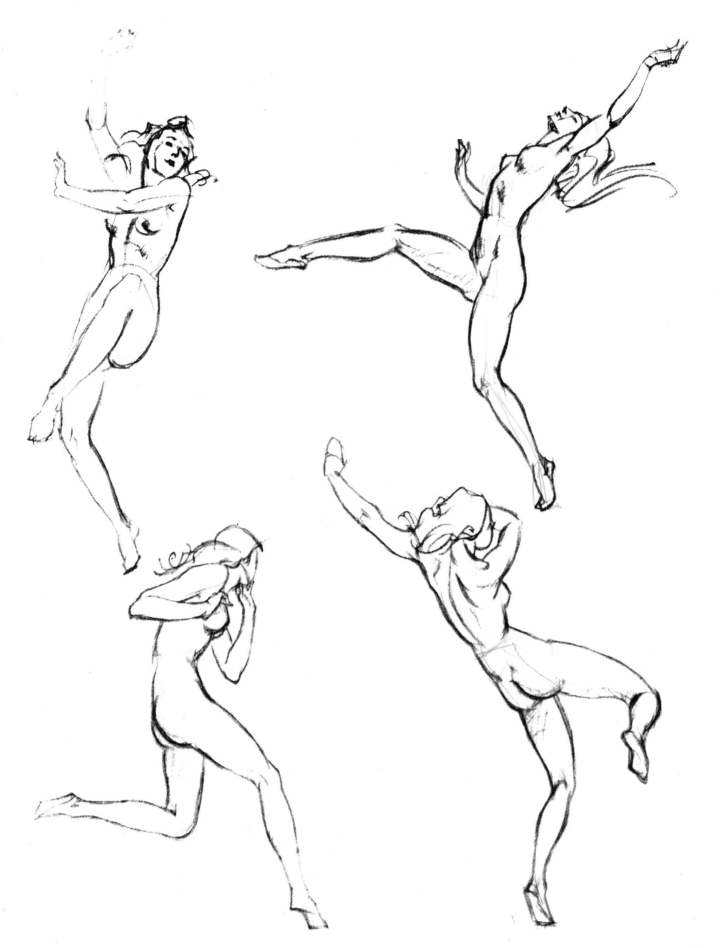

FIGURE SKETCHING

One of the most fascinating subjects to draw is the human figure.

The fine proportions, beautiful modeling and delicate balance, and the infinite variations in movement and repose are such that there is no other living thing to compare with it.

Through countless ages artists of all races have drawn, painted, and modeled the human form.

If you have never done any figure drawing, I would suggest that you start to draw the human figure in its simplest pose with little or no foreshortening. This is an upright standing position with arms close to the body and feet together.

Make up your mind before you begin, how large you want your drawing to be and mark on your paper the total length desired. Your drawing must be exactly the size that you have indicated on your paper.

Your next step is to draw a straight, vertical line connecting the two marks. This will indicate the imaginary line of gravitation running from head to foot.

Now mark the center of the body by dividing the vertical line into two equal parts. Mark your proportions.

Draw in the oval of the head.

Measure the width of the shoulders compared to the length of the body. Draw in the shoulder line. Do the same with the hips.

(To measure, use a pencil in your outstretched hand, first getting the width, then measuring vertically the number of times the width goes into the total length of the body.) Now proceed to draw the masses of the chest, hips, legs, etc.

To check on your drawing, watch the shape of the *background* that surrounds the figure. See if these "left spaces" (or negative shapes) correspond with the outline of your drawing.

For instance, whatever the position of your subject, watch the shape and size of the *space* between the arms and the body; between the tilted head and the shoulder; between the two legs, etc., etc.

These will be your *left spaces*. Special attention to them will be of great help in making a correct drawing.

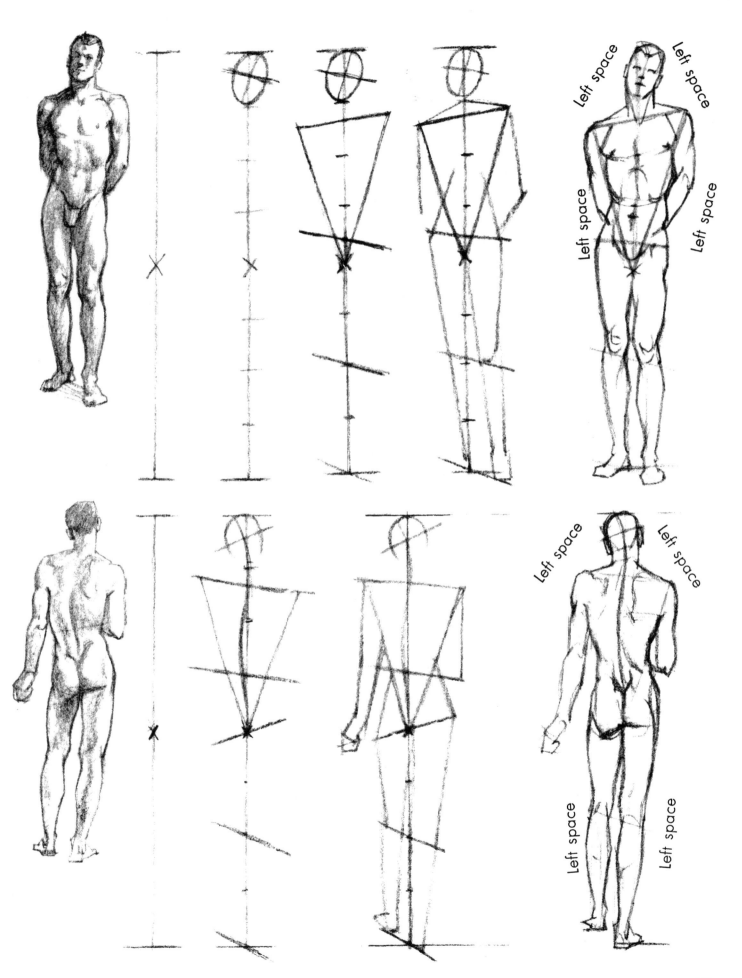

Left space

Left space

Left space

Left space

Left space

Left space

Left space

Left space

75

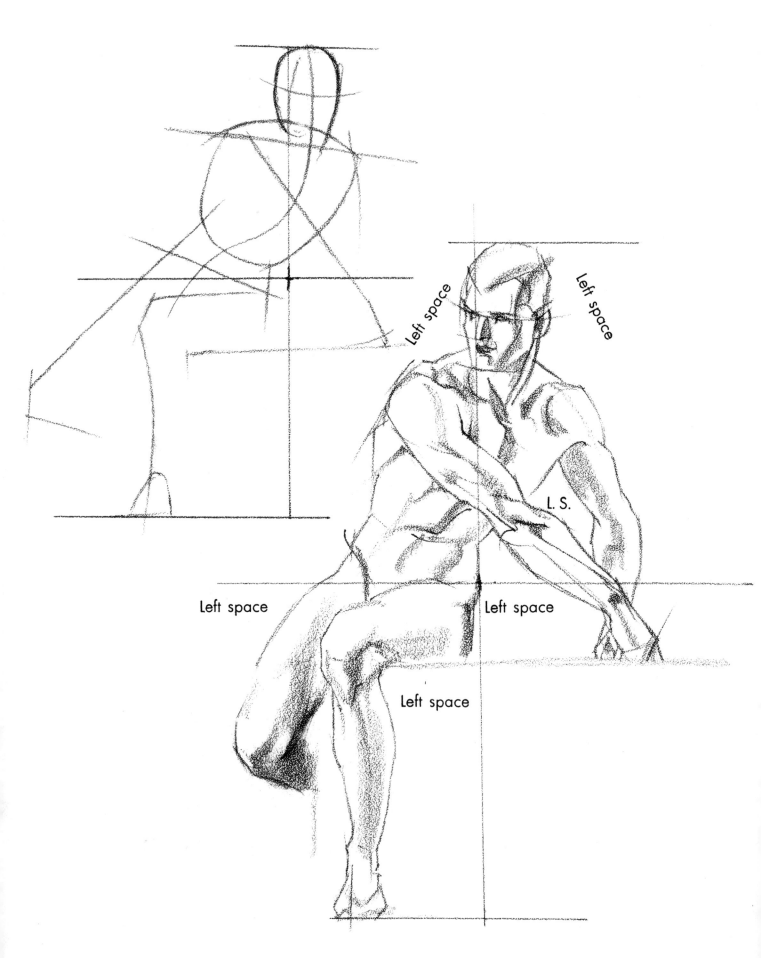

Left space

Left space

L. S.

Left space

Left space

Left space

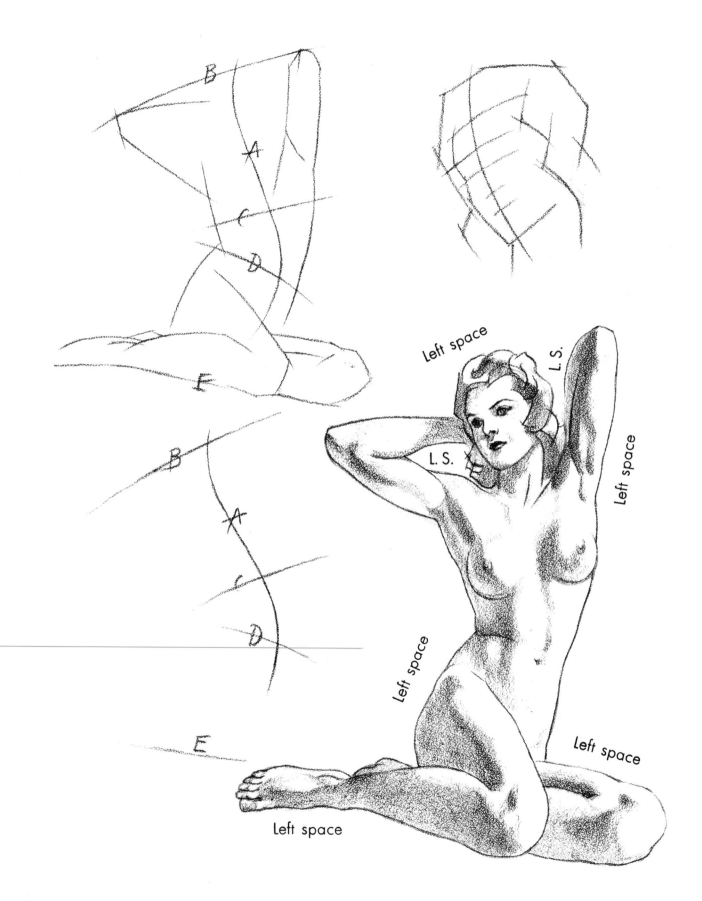

B

A

C

D

F

B

A

C

D

E

Left space

Left space

L.S.

L.S.

Left space

Left space

Left space

Left space

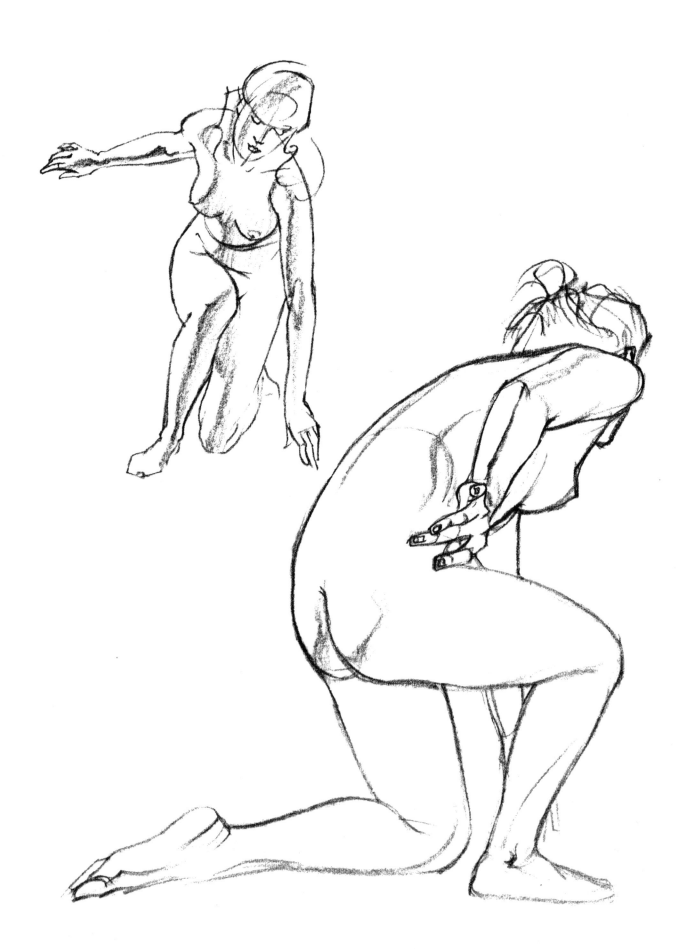

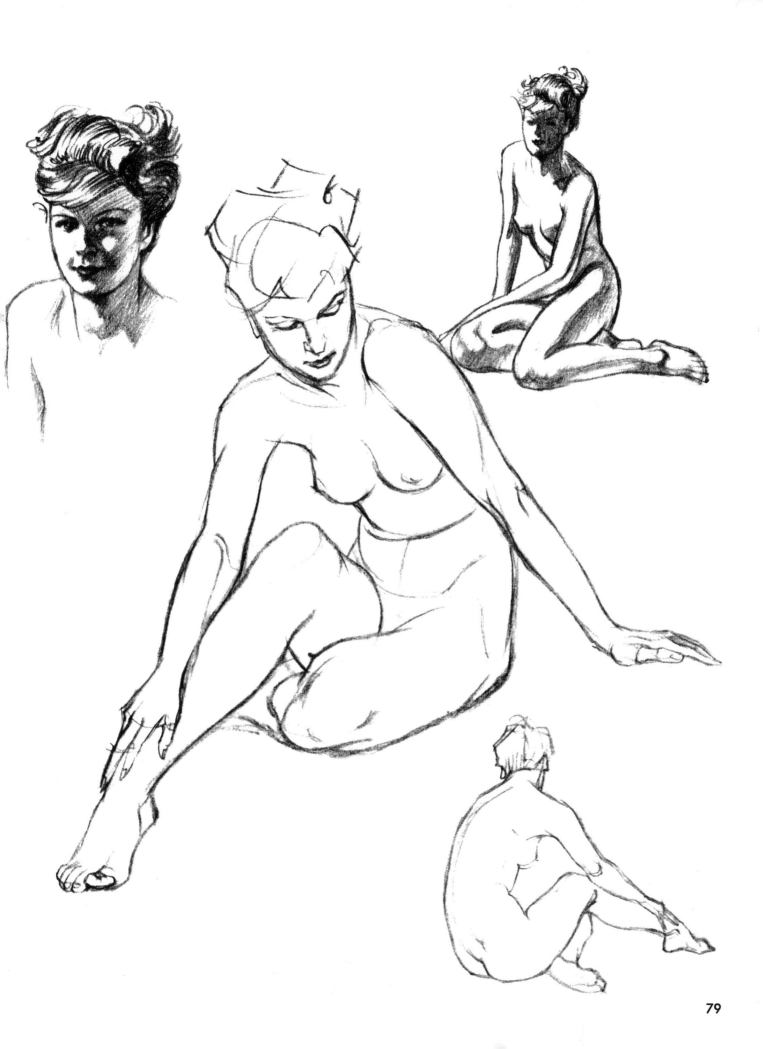

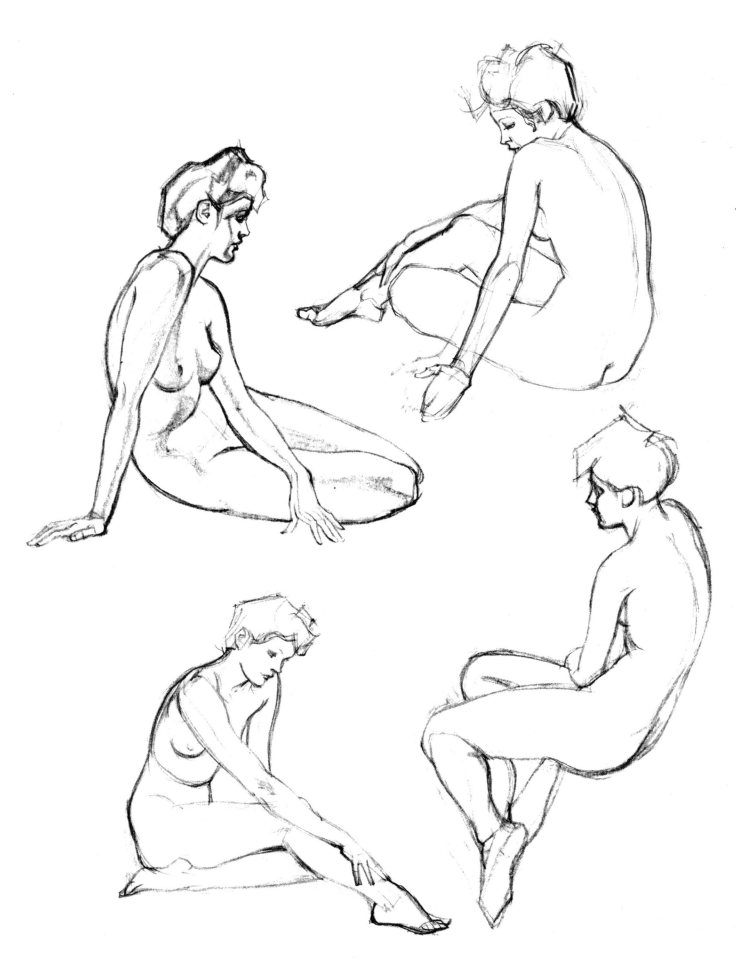

80

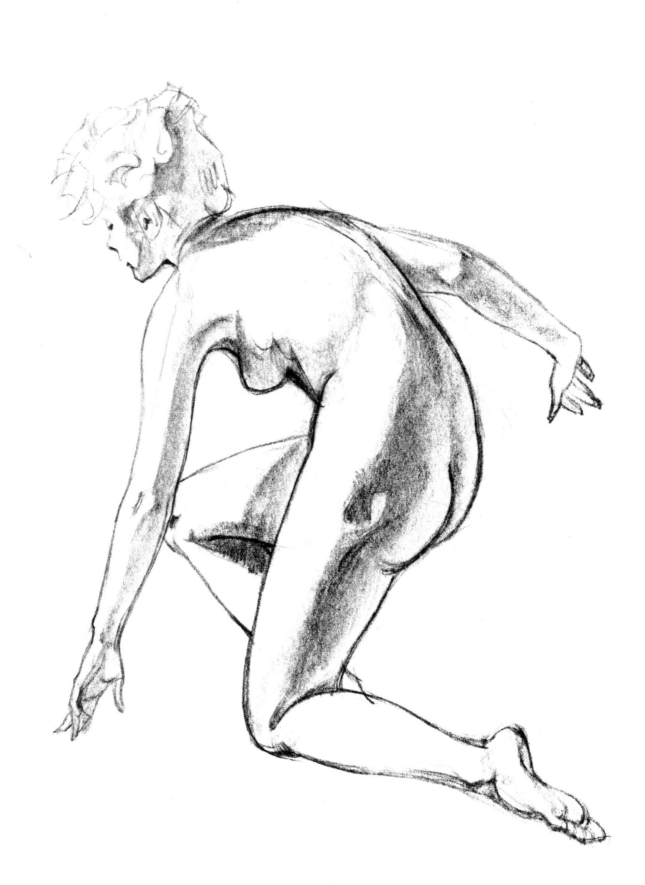

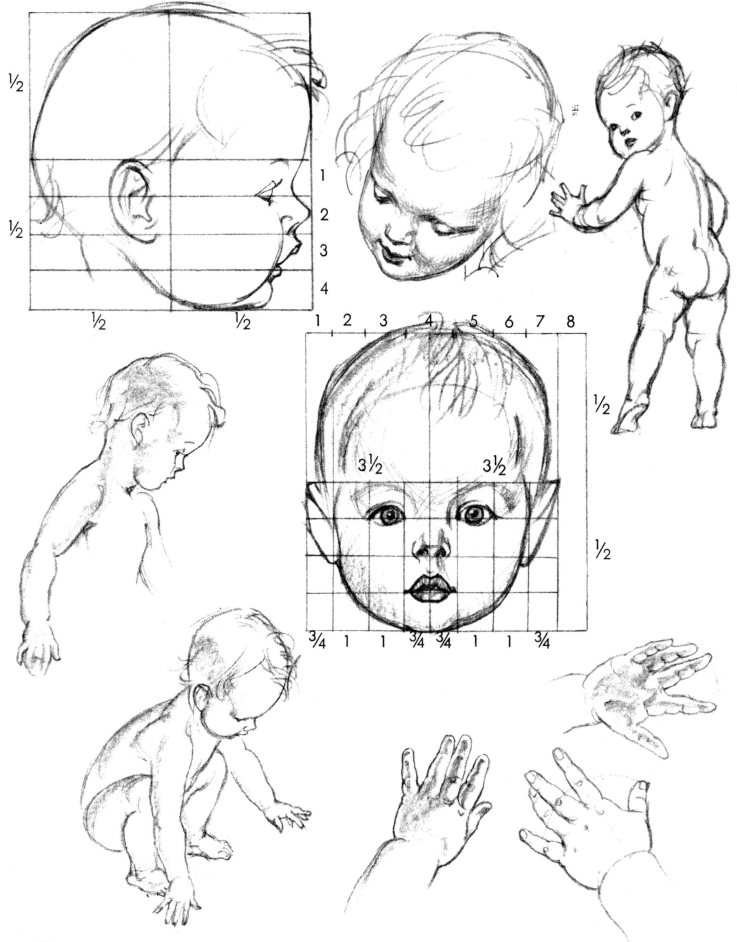

½

½

½

½

1
2
3
4

½ ½

1 2 3 4 5 6 7 8

3½ 3½

½

½

¾ 1 1 ¾ ¾ 1 1 ¾

82

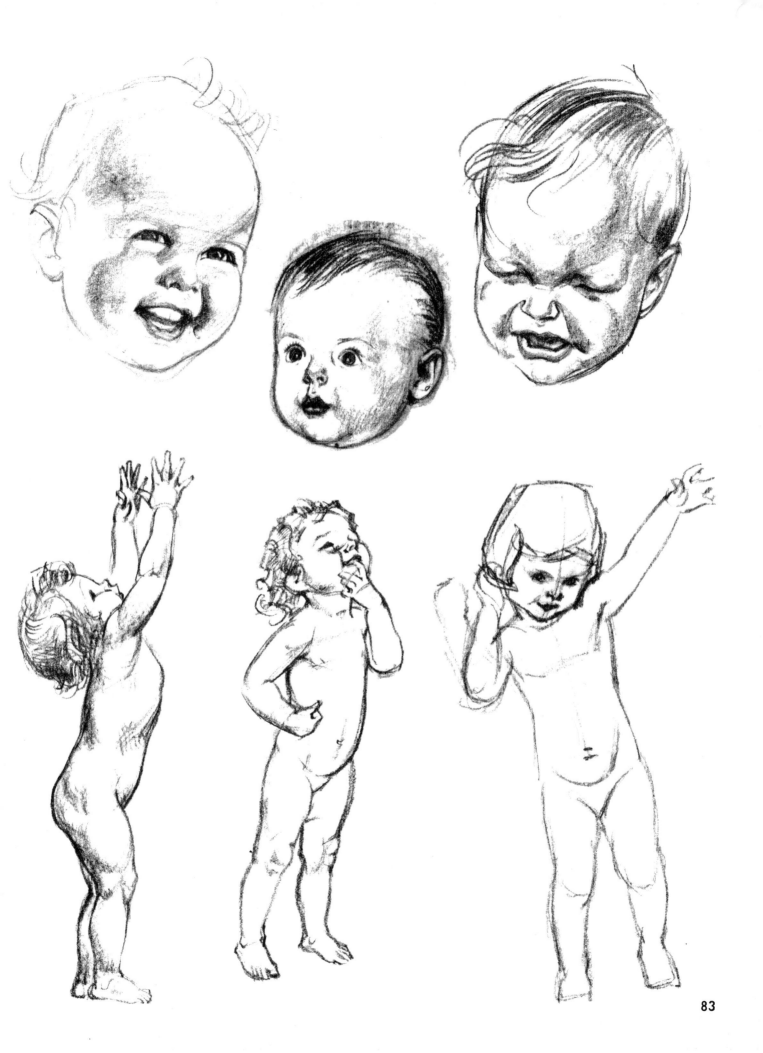

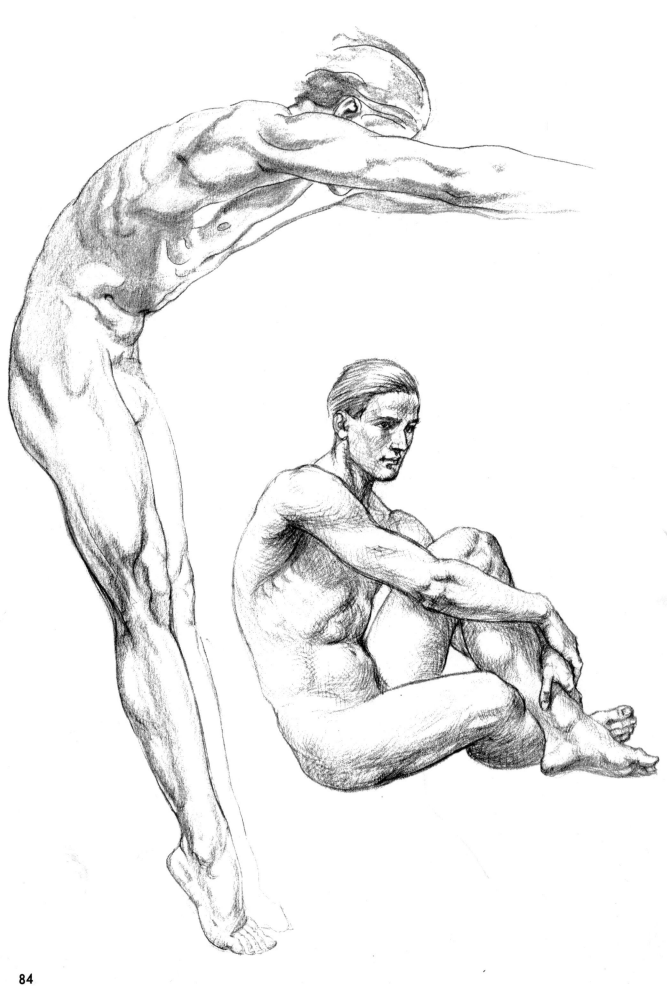

84

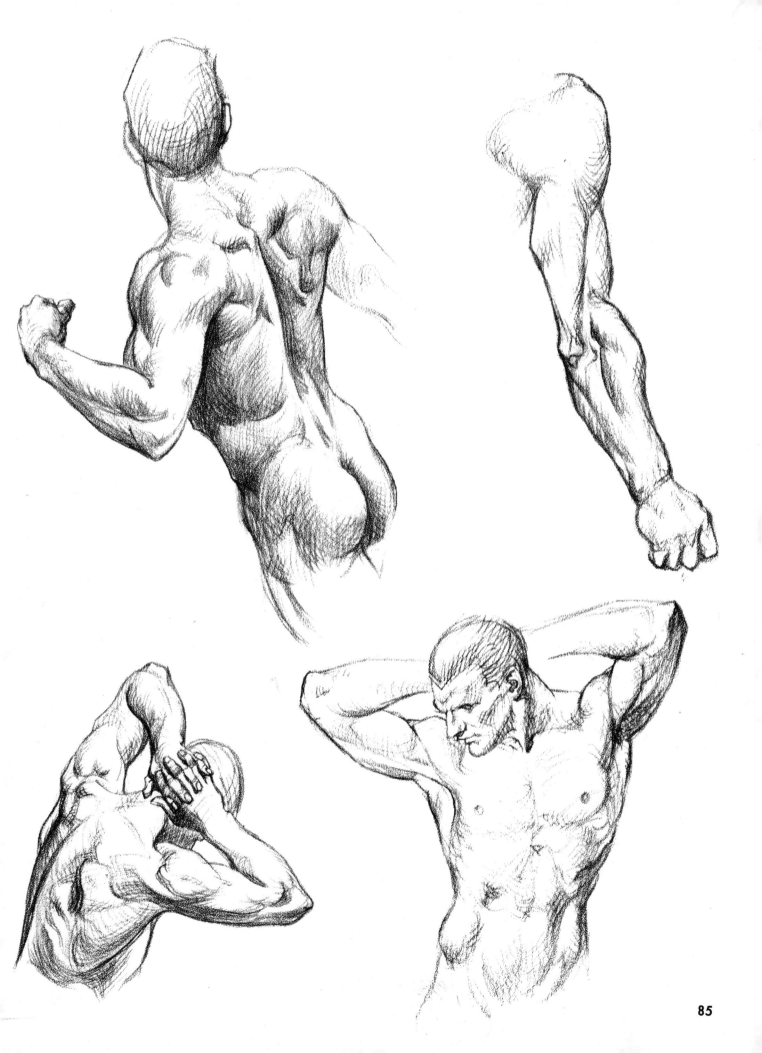

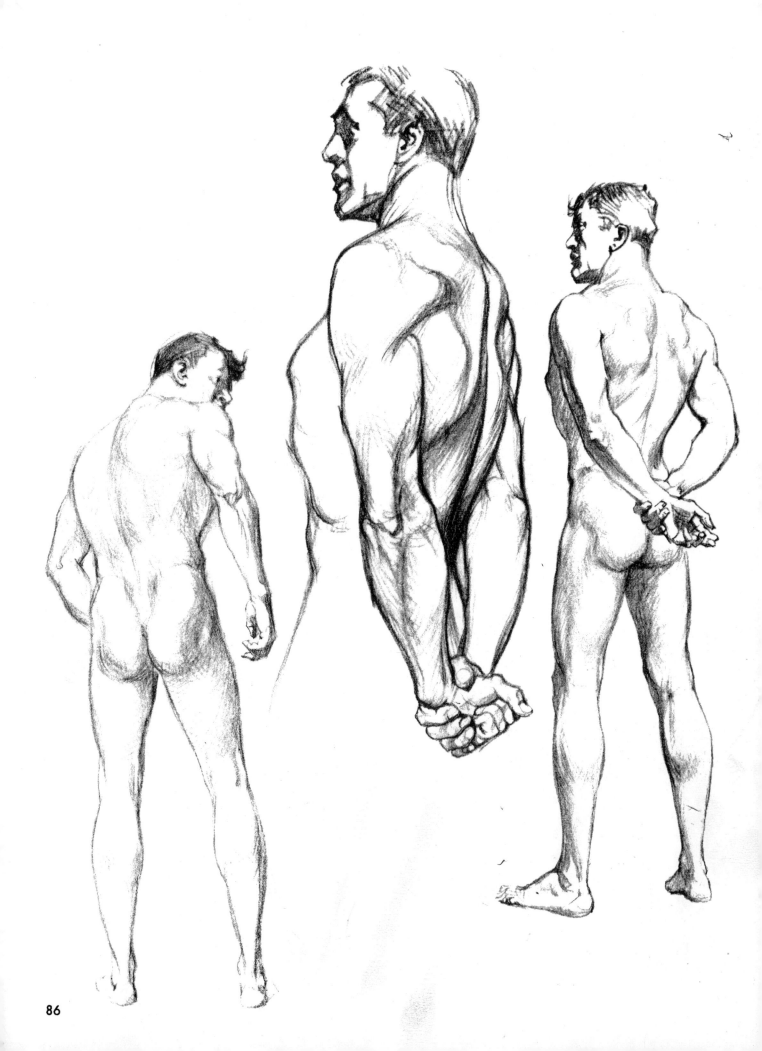

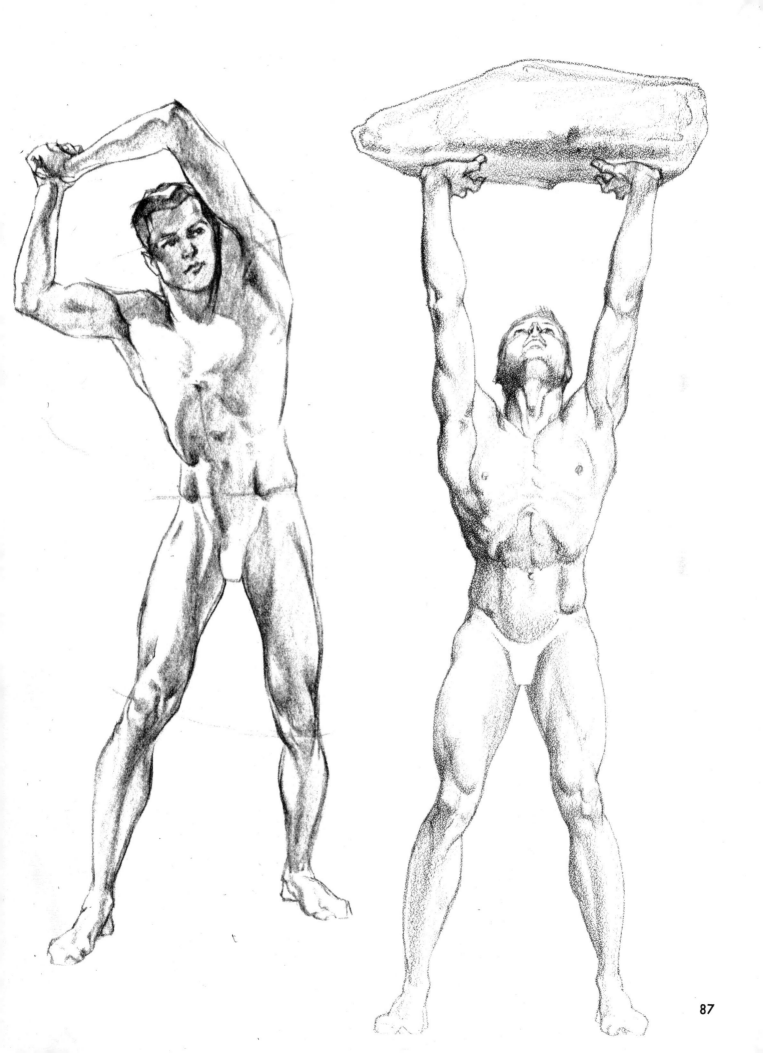

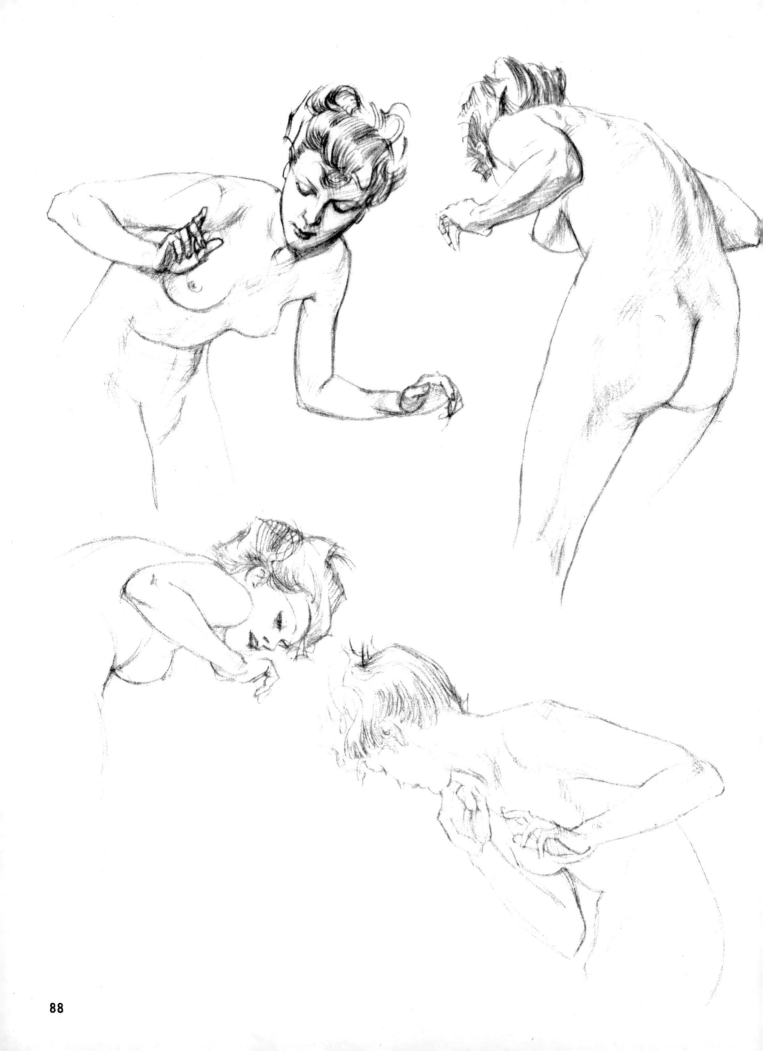

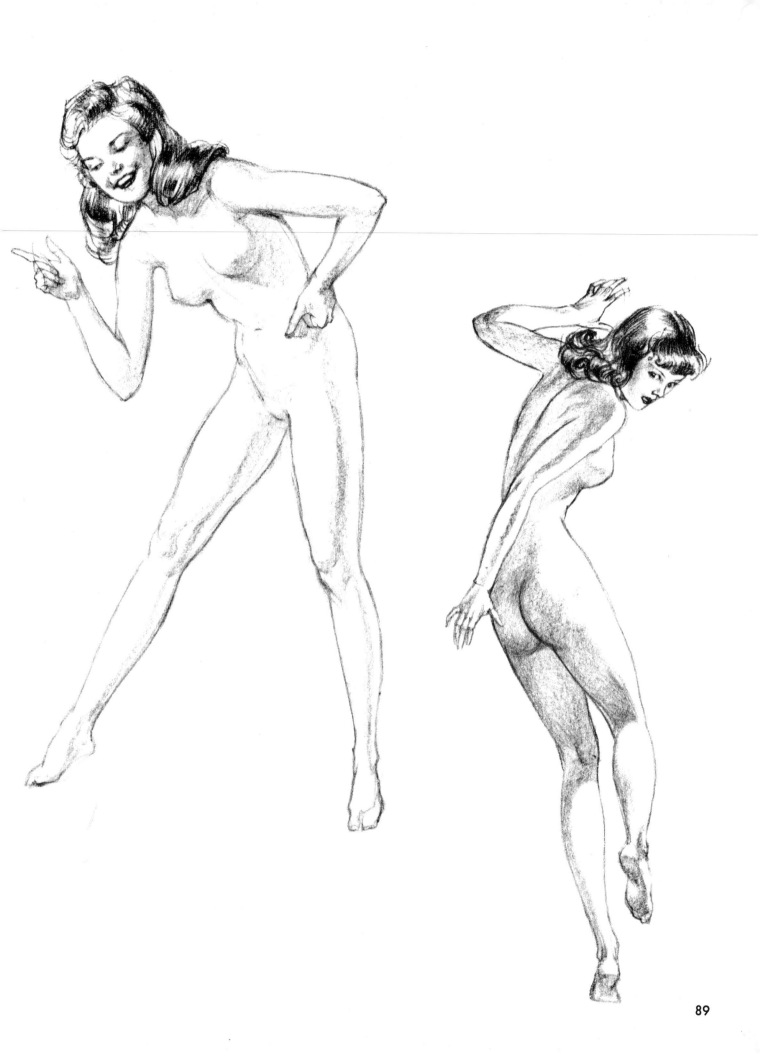

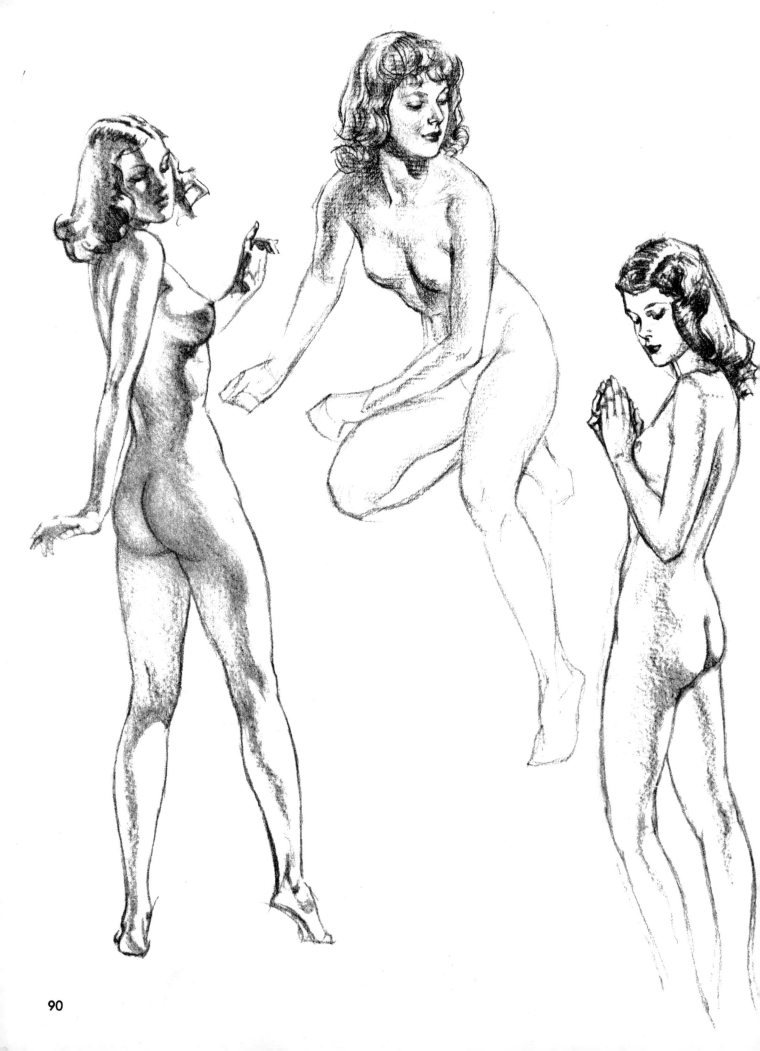

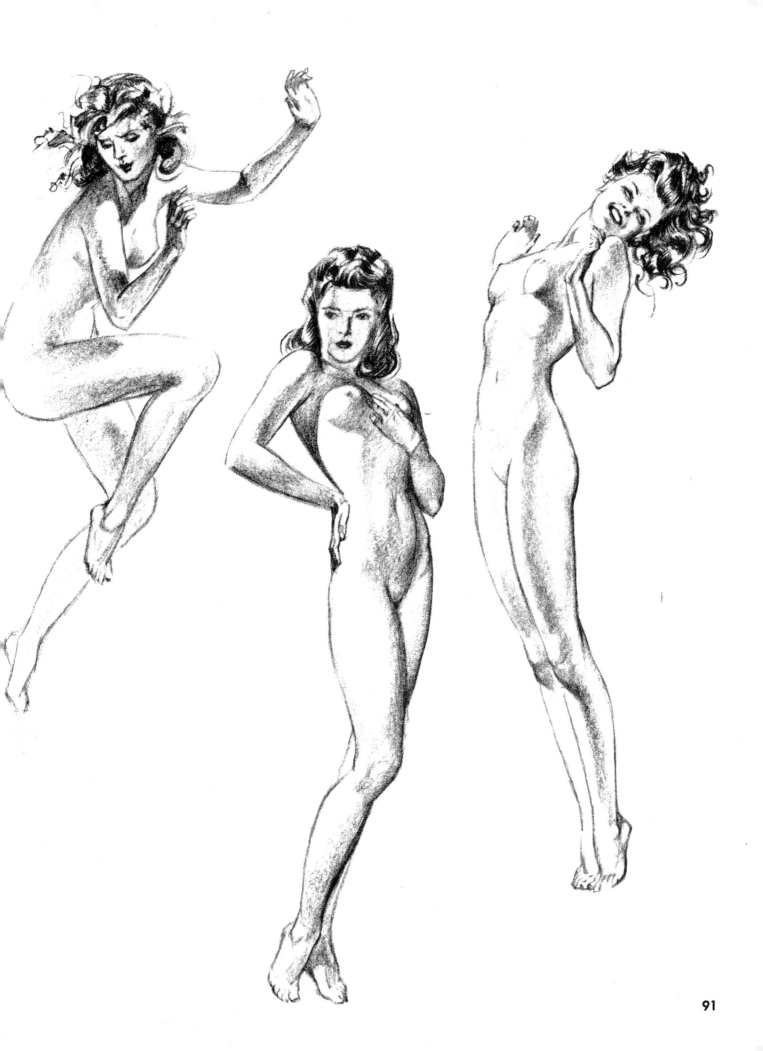

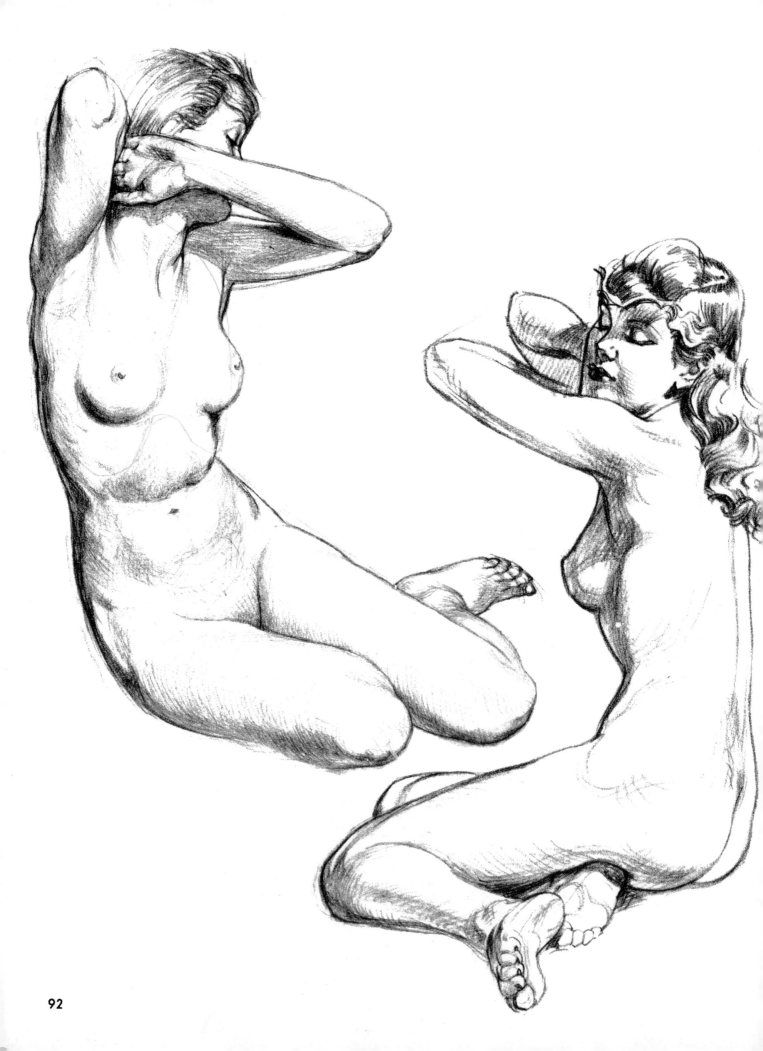

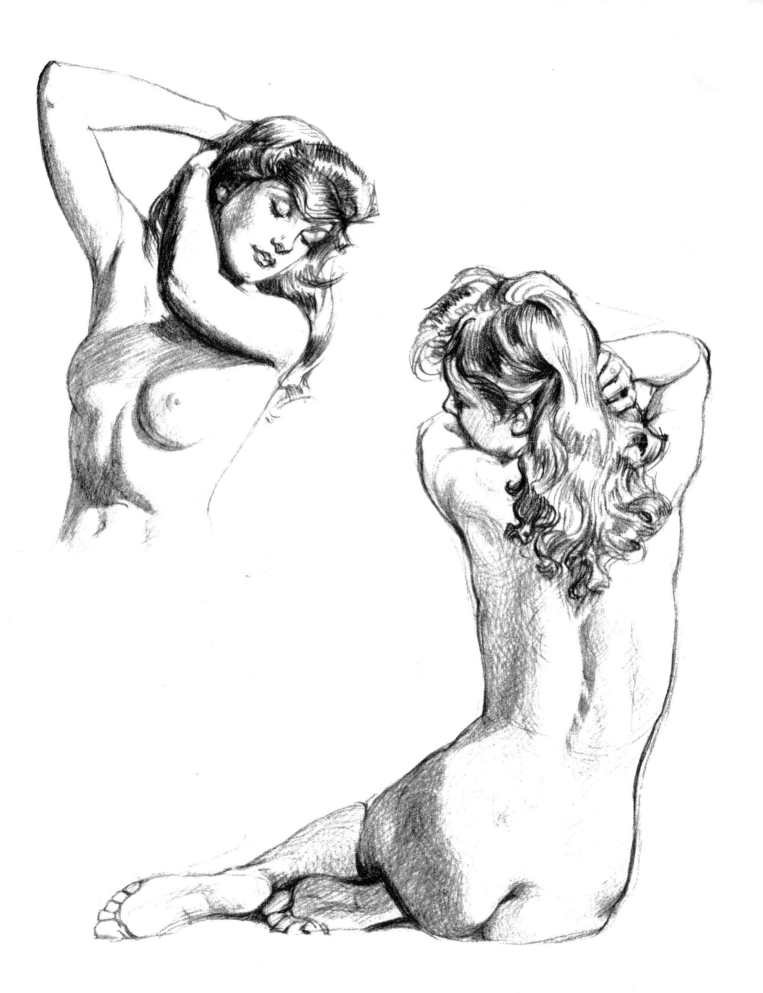

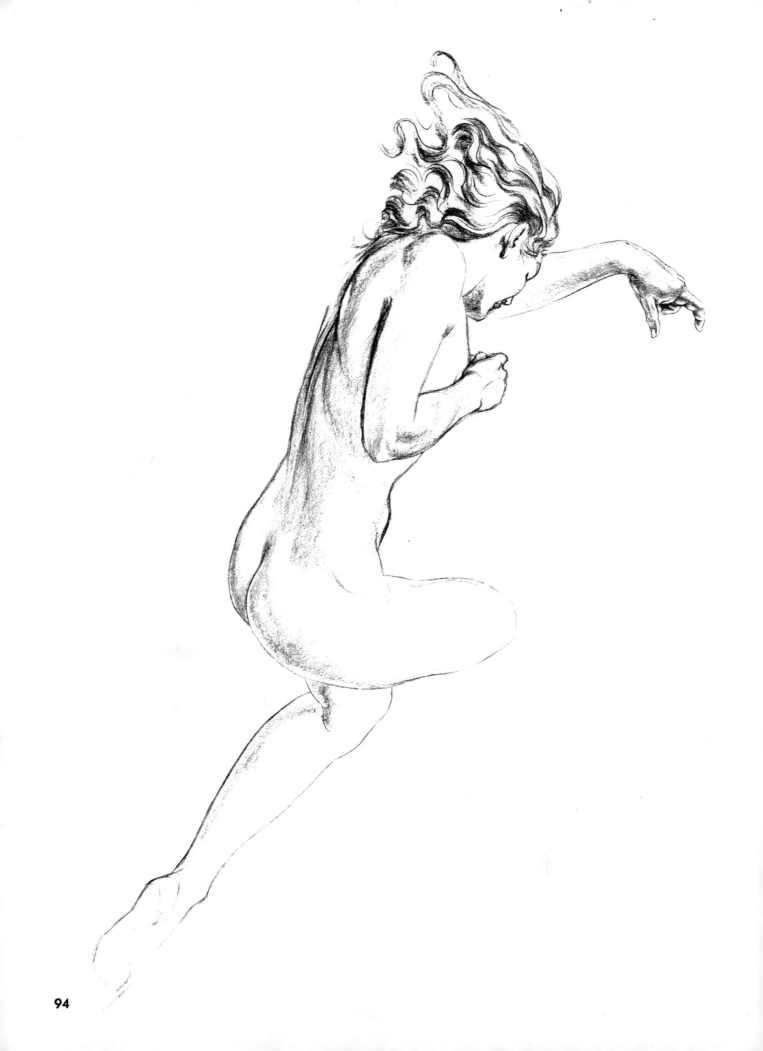

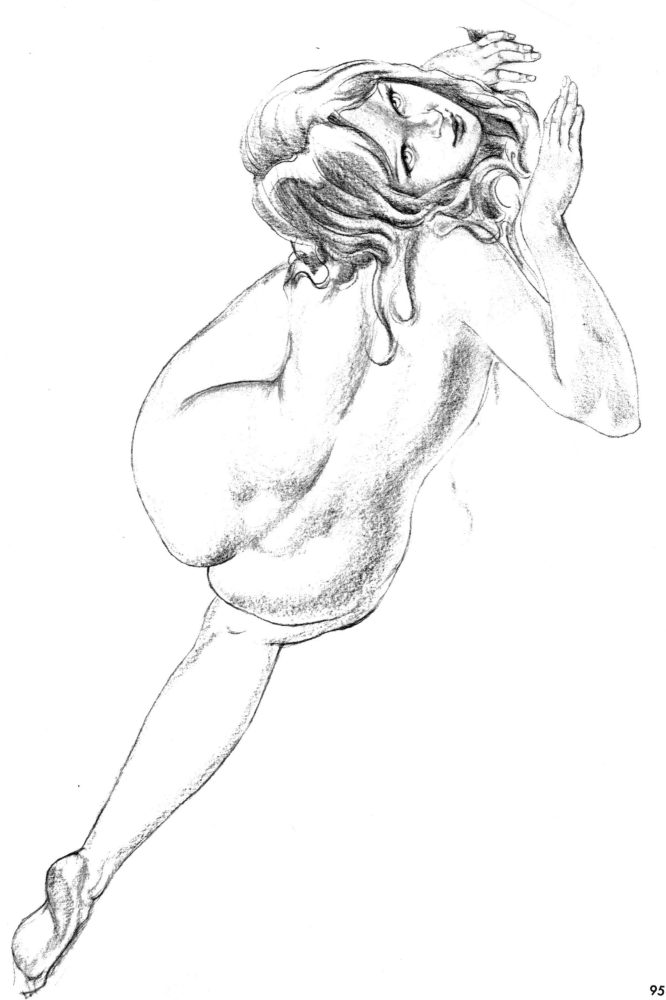

95

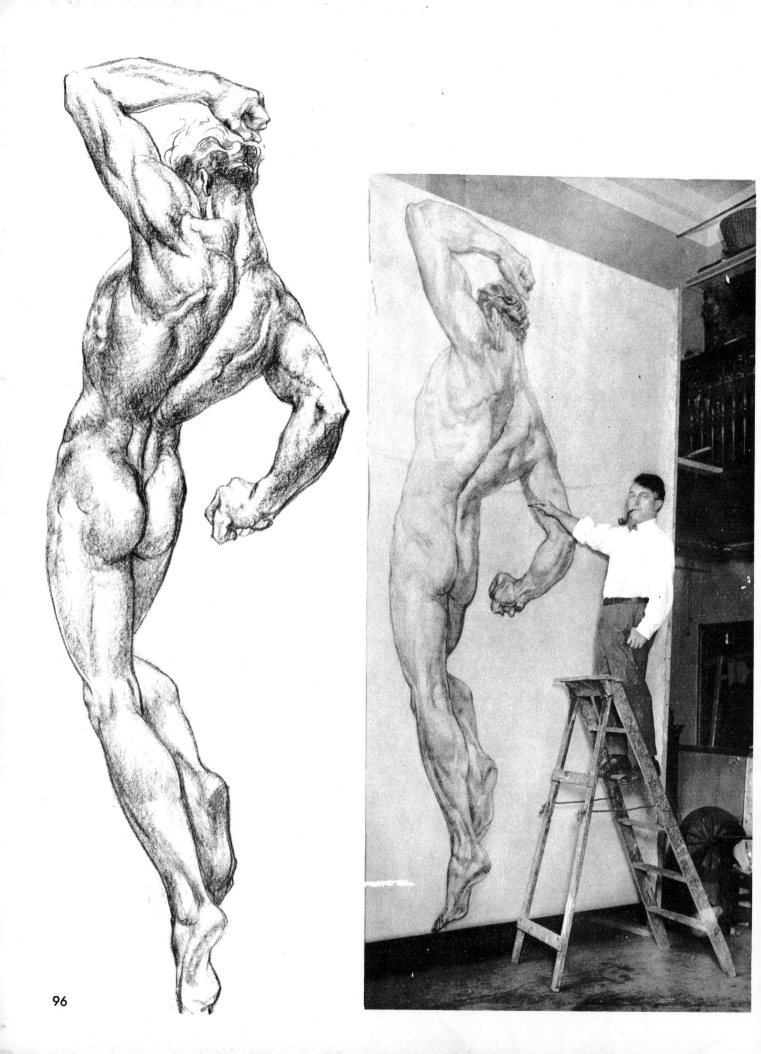

Sketches and Studies

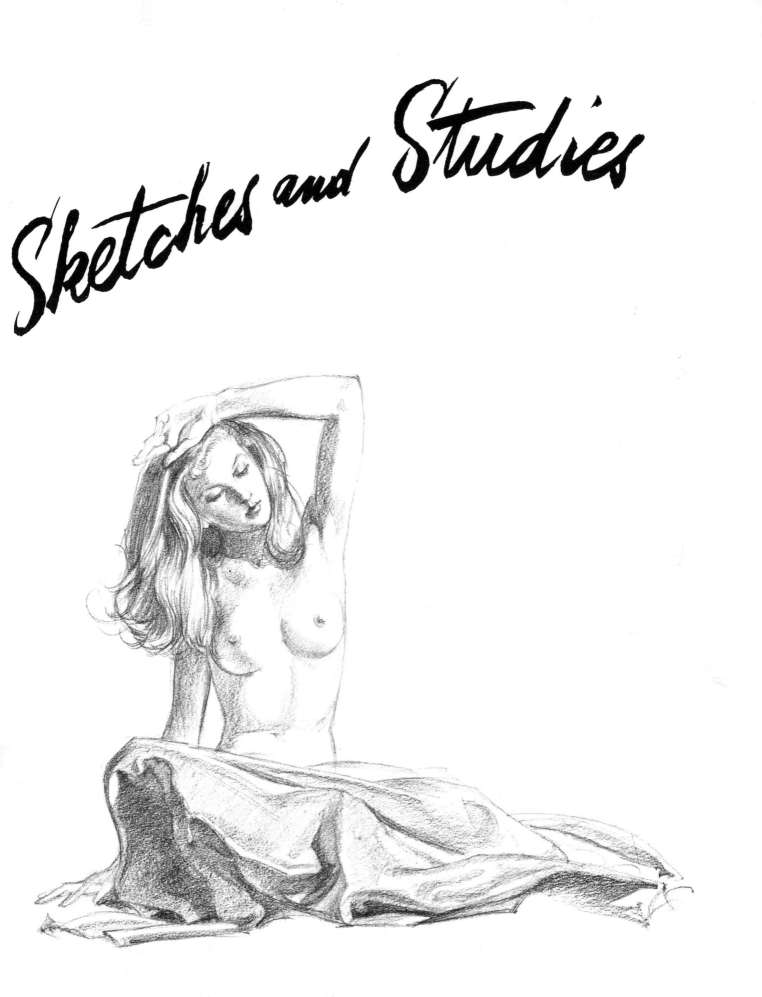

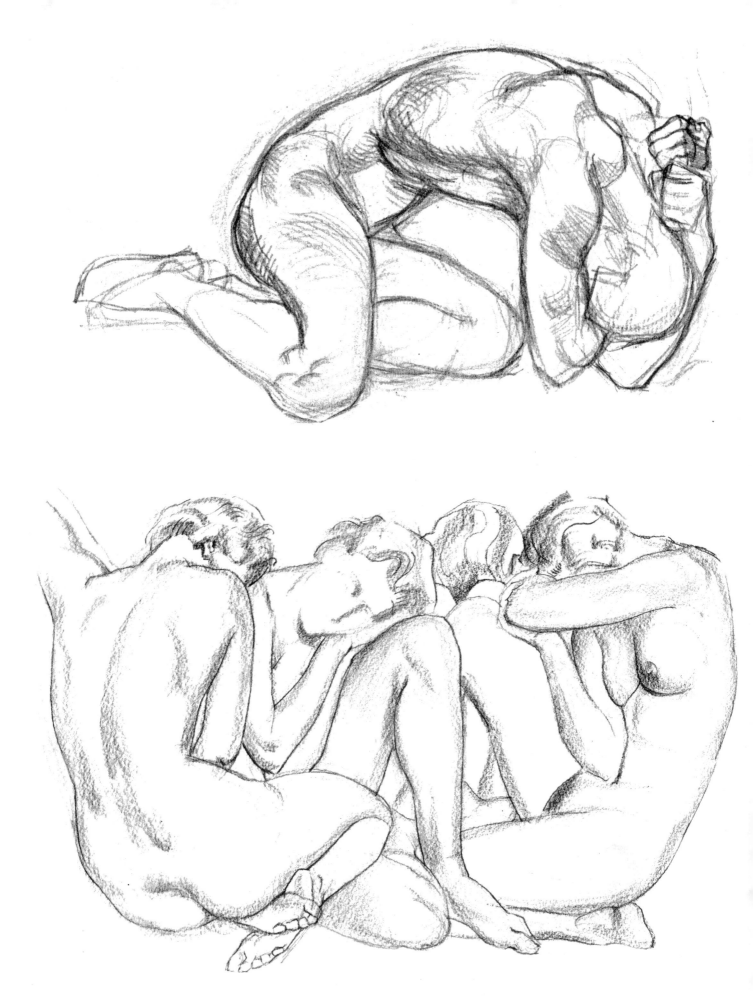

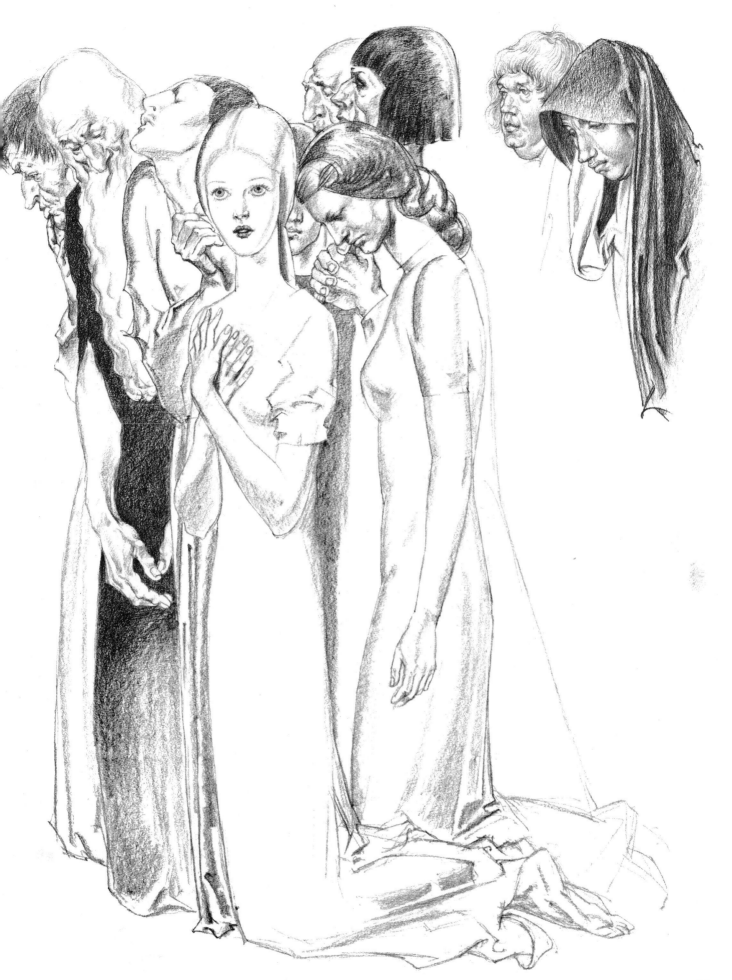

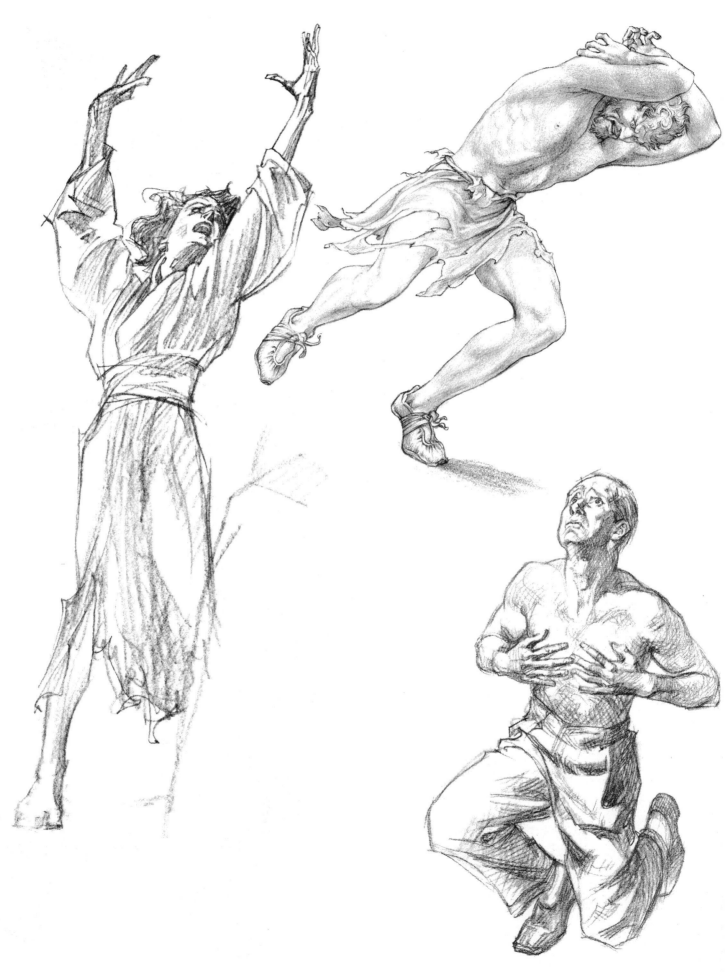

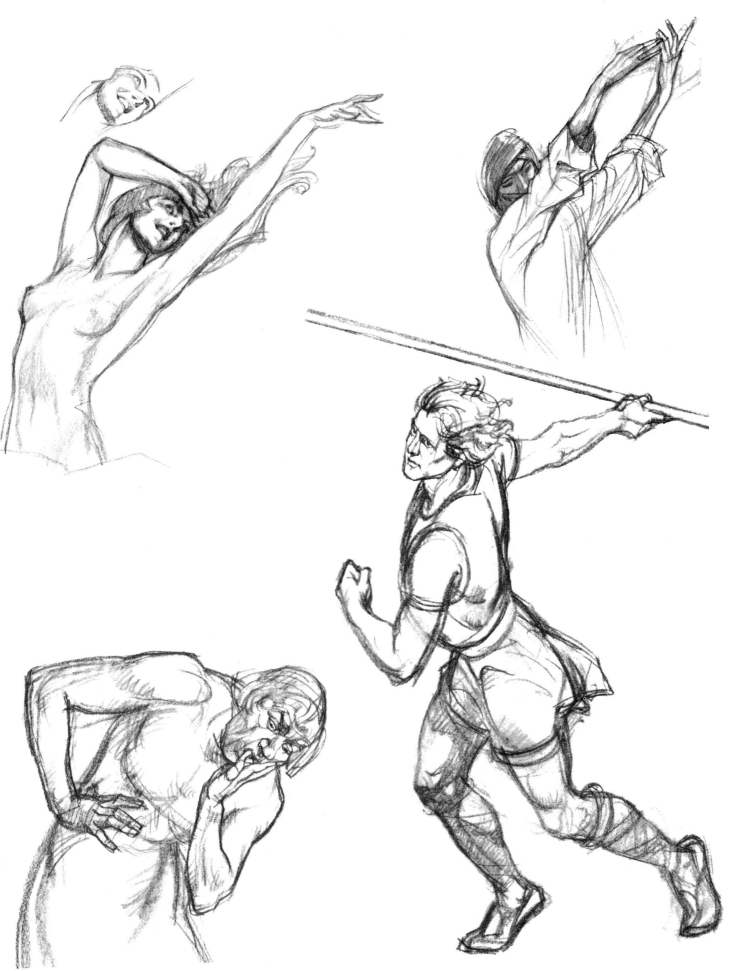

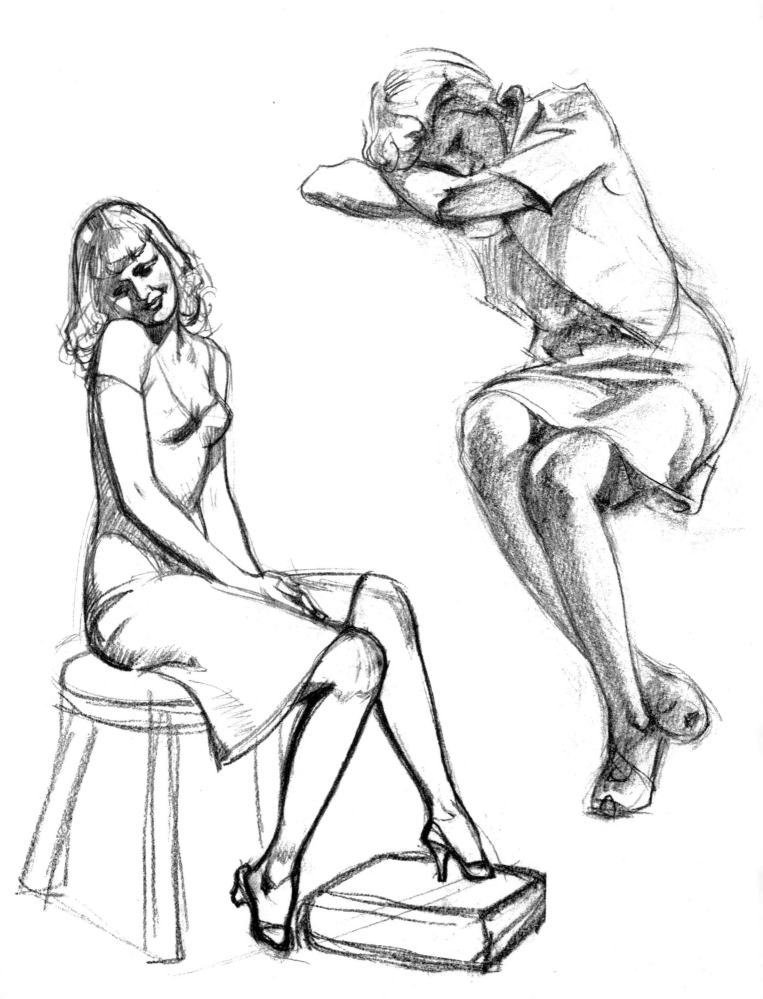

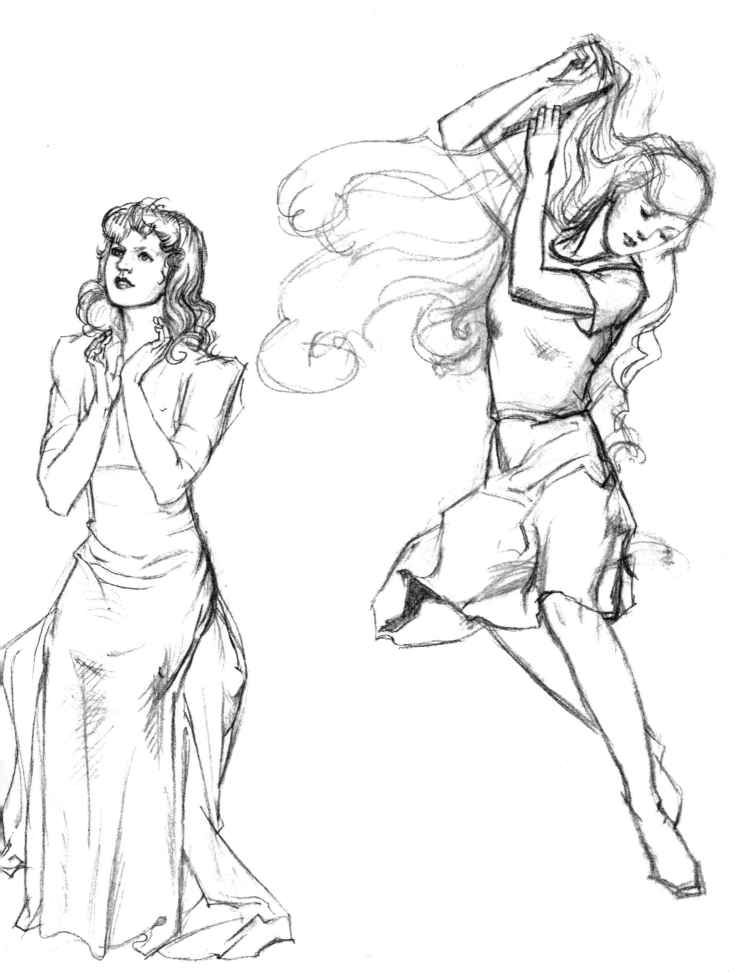

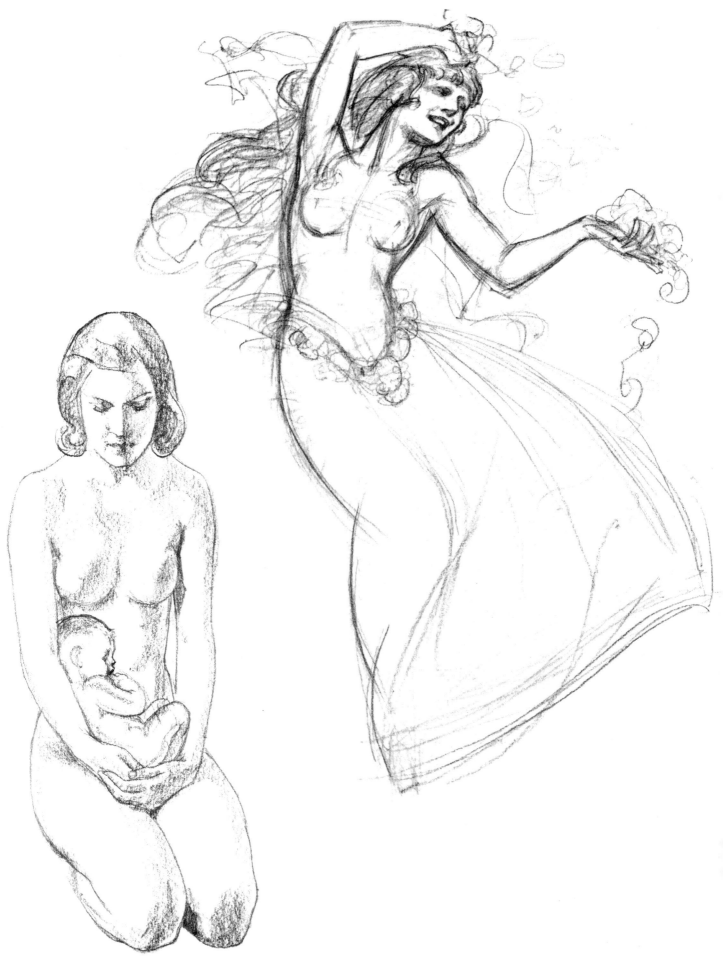

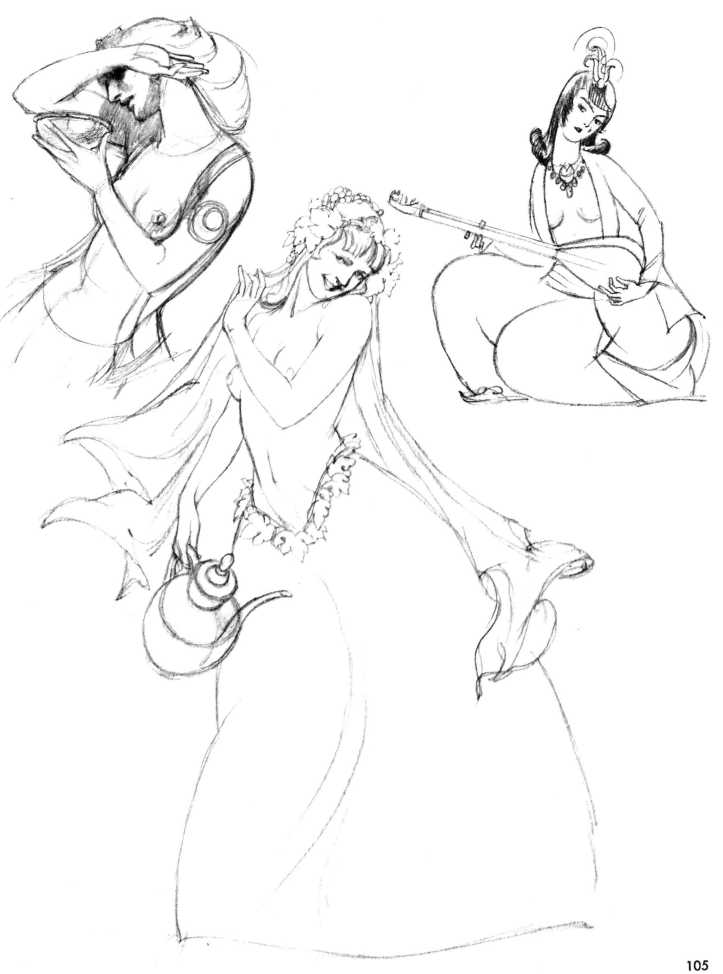

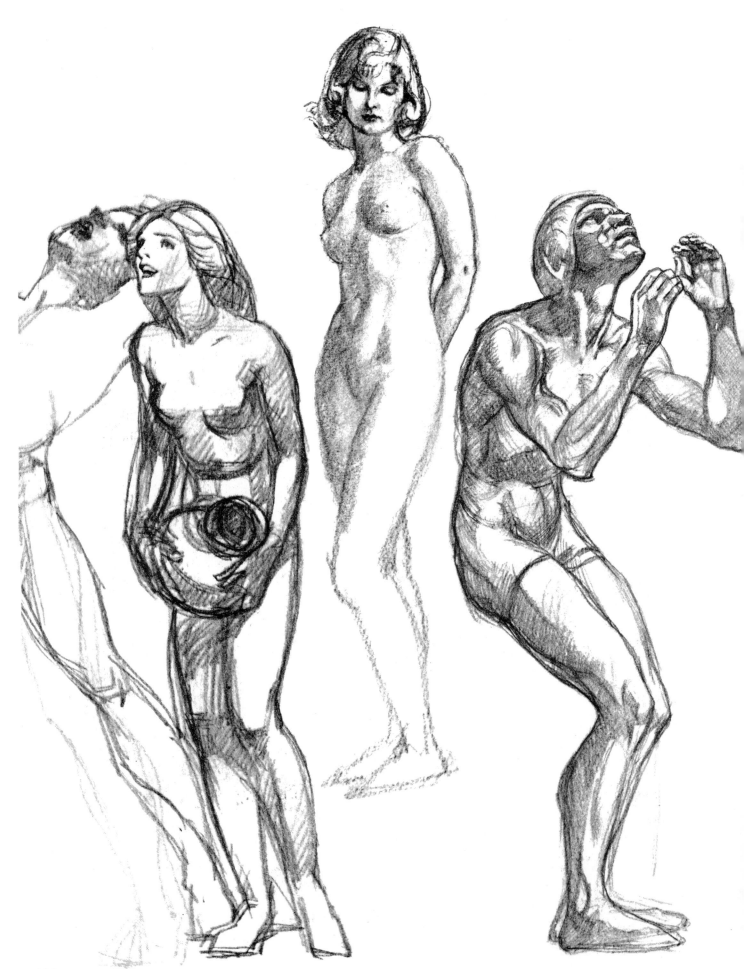

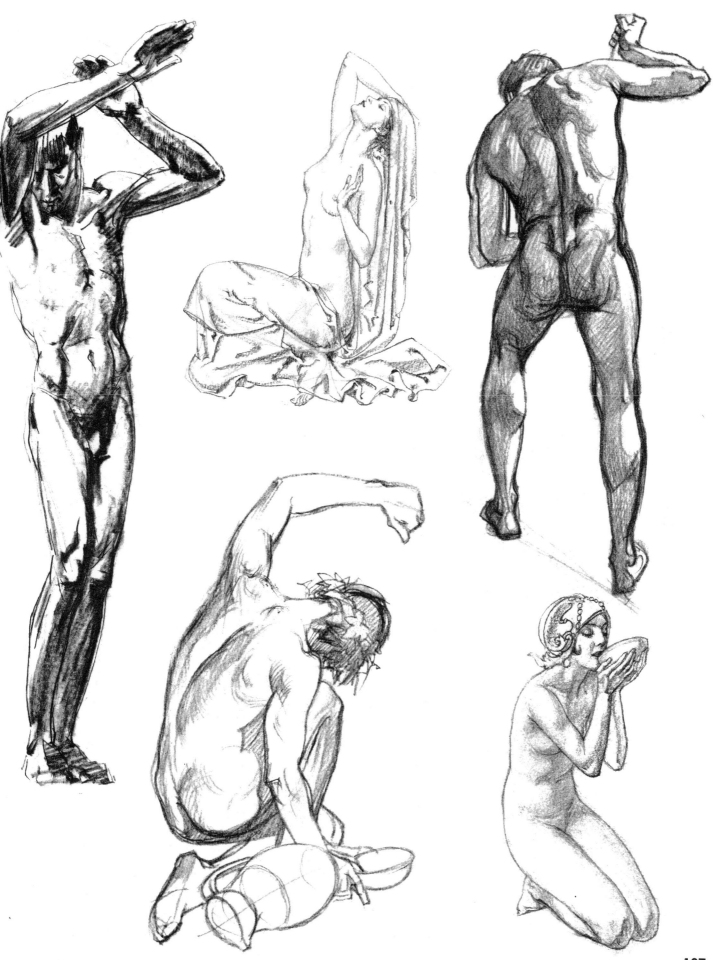

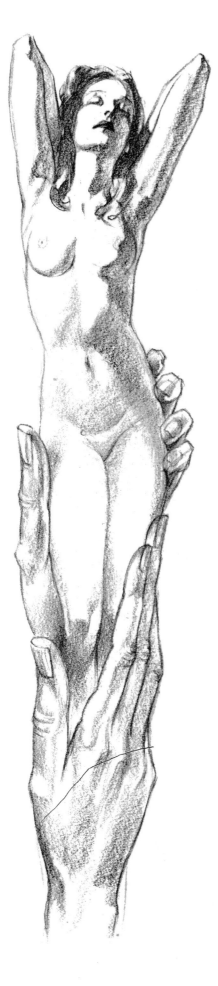
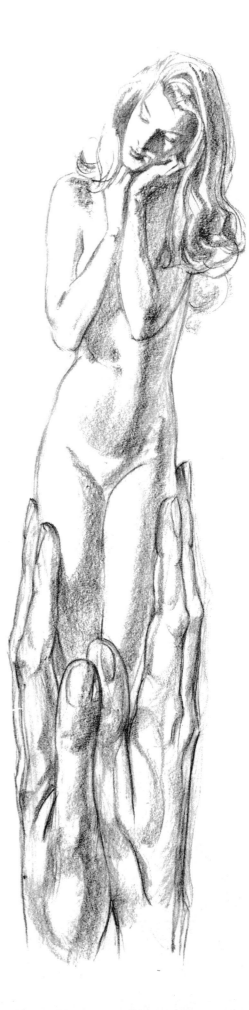

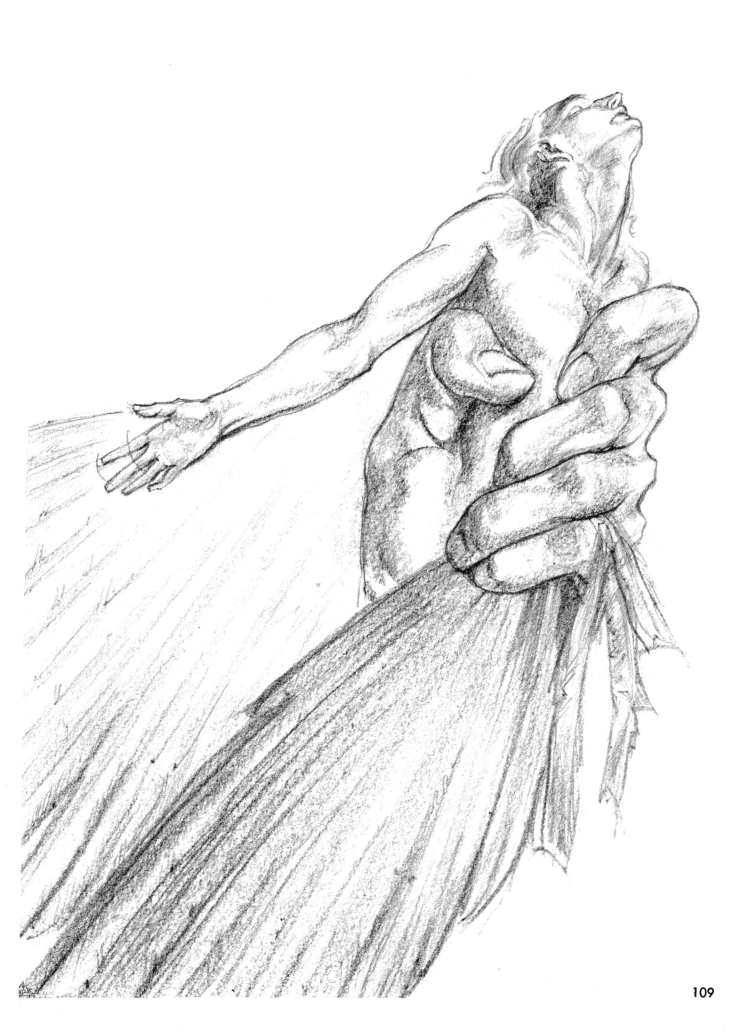

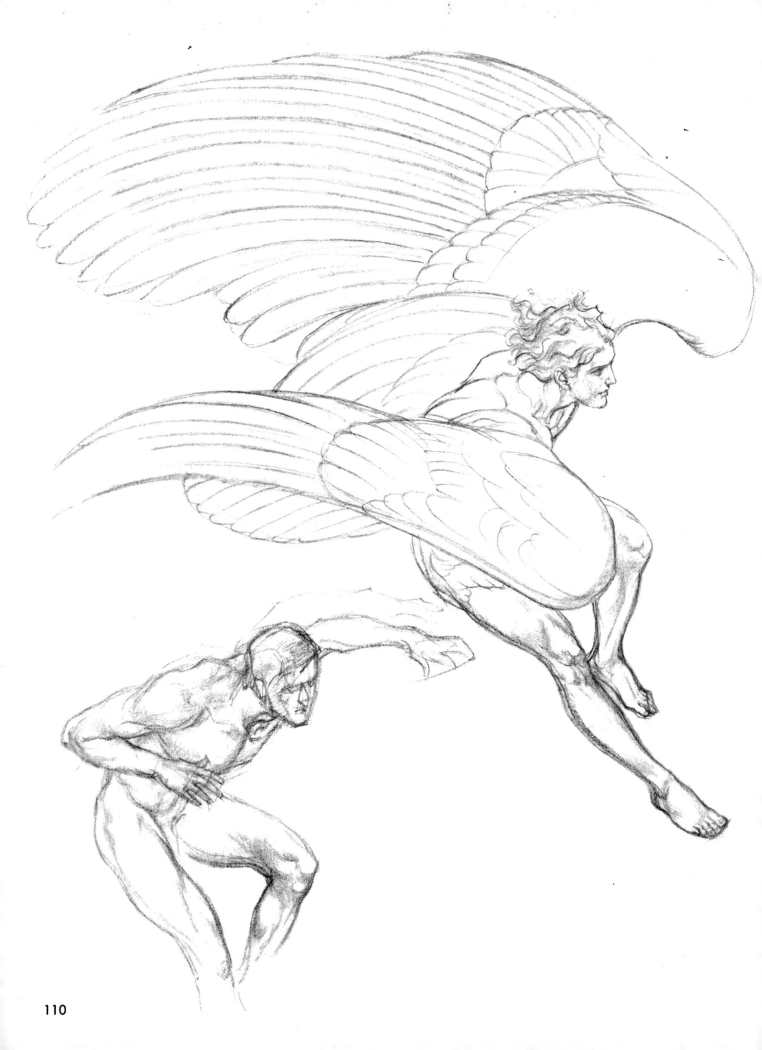

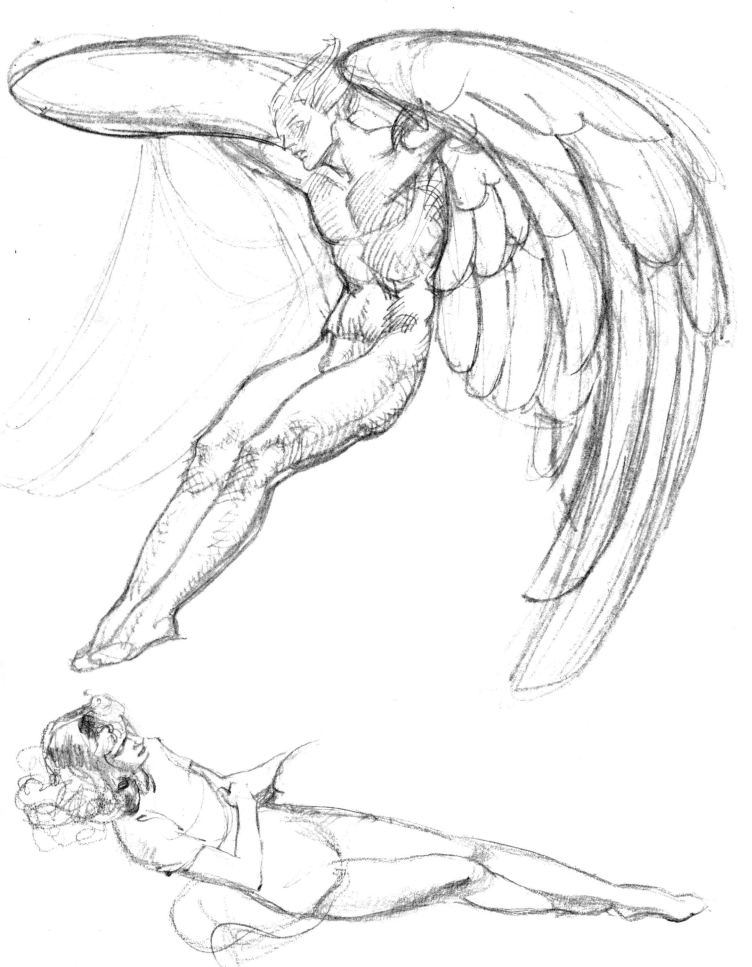

112

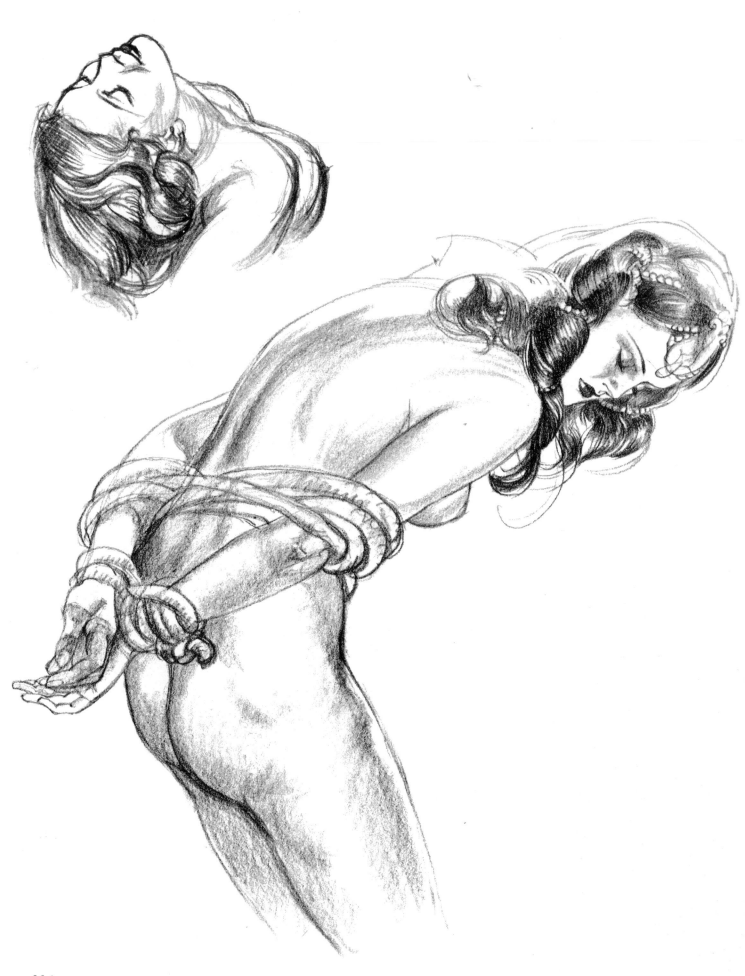

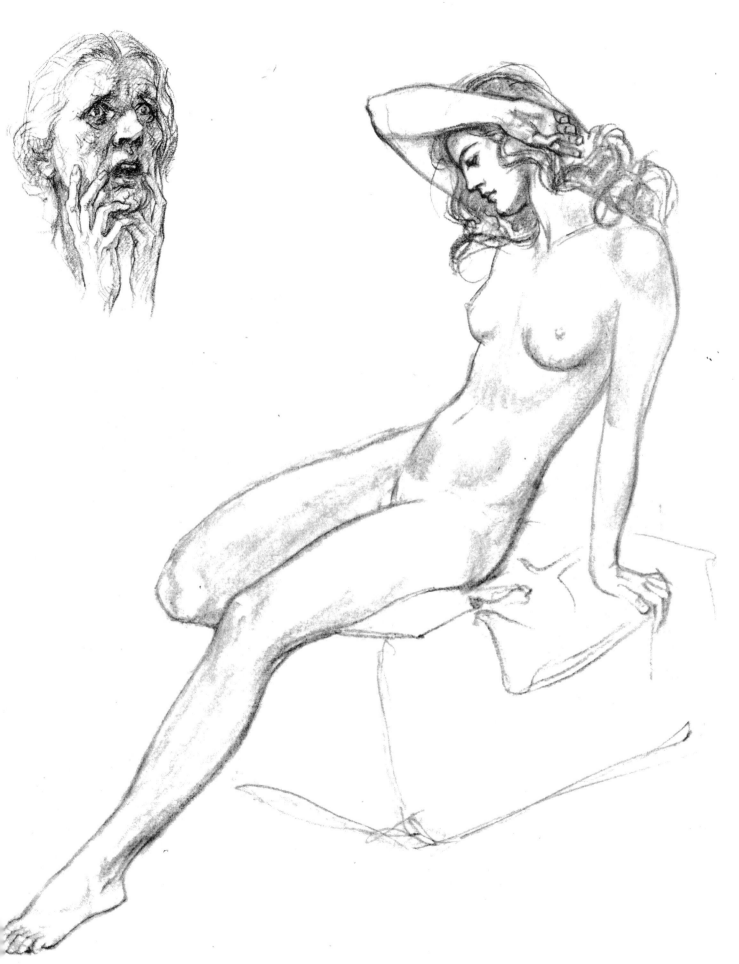

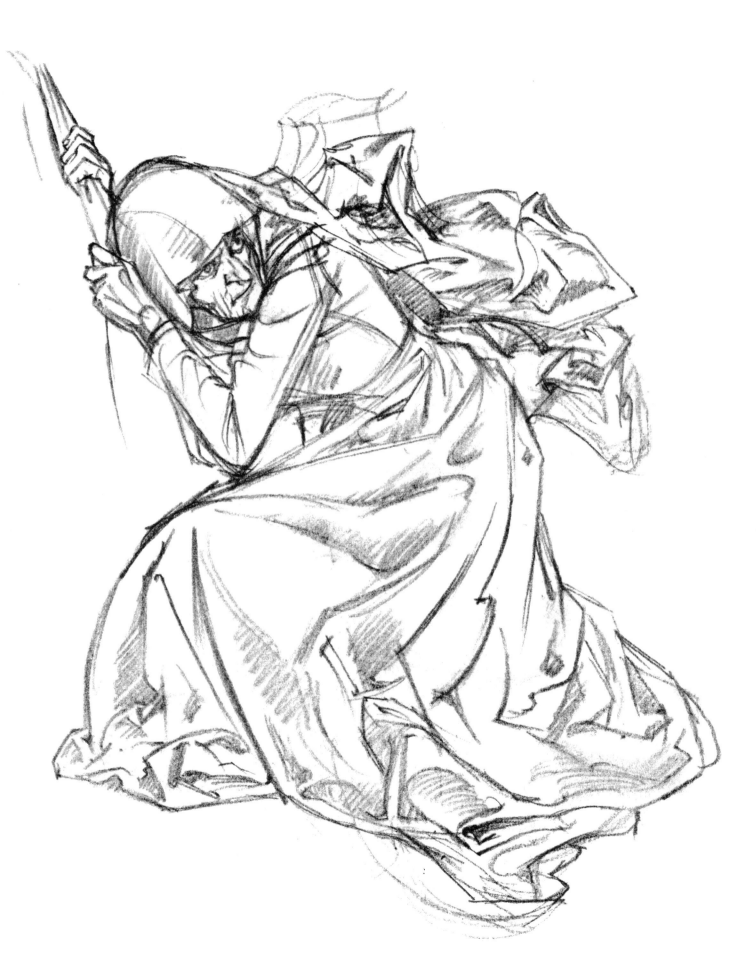

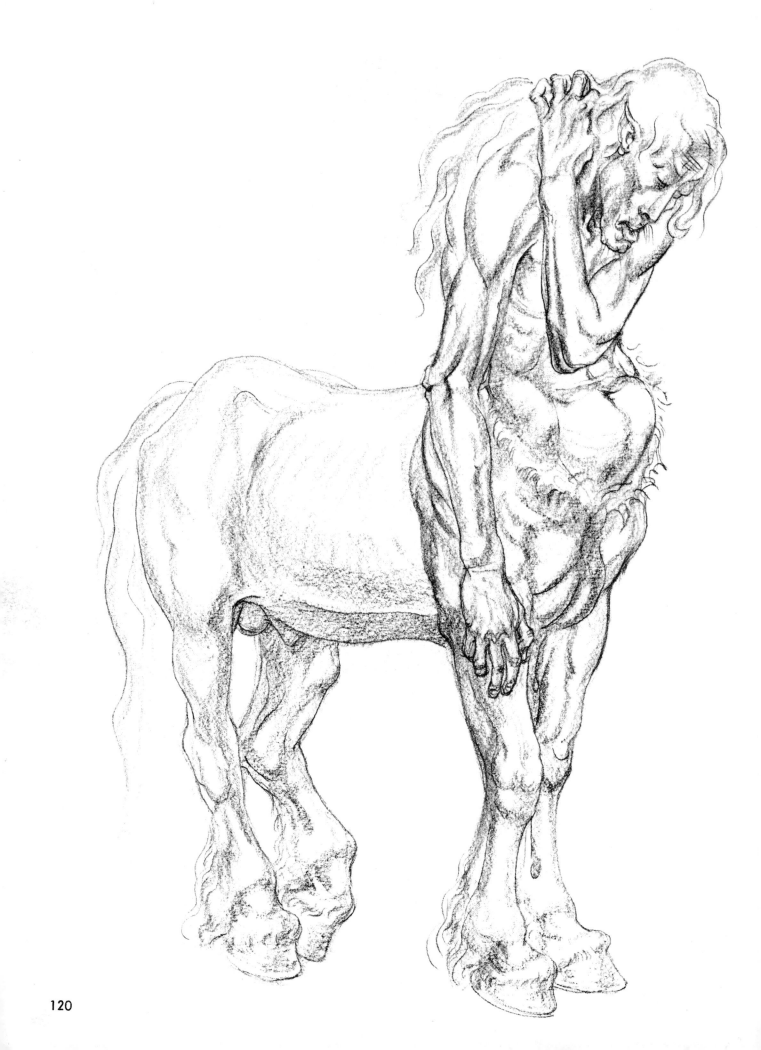

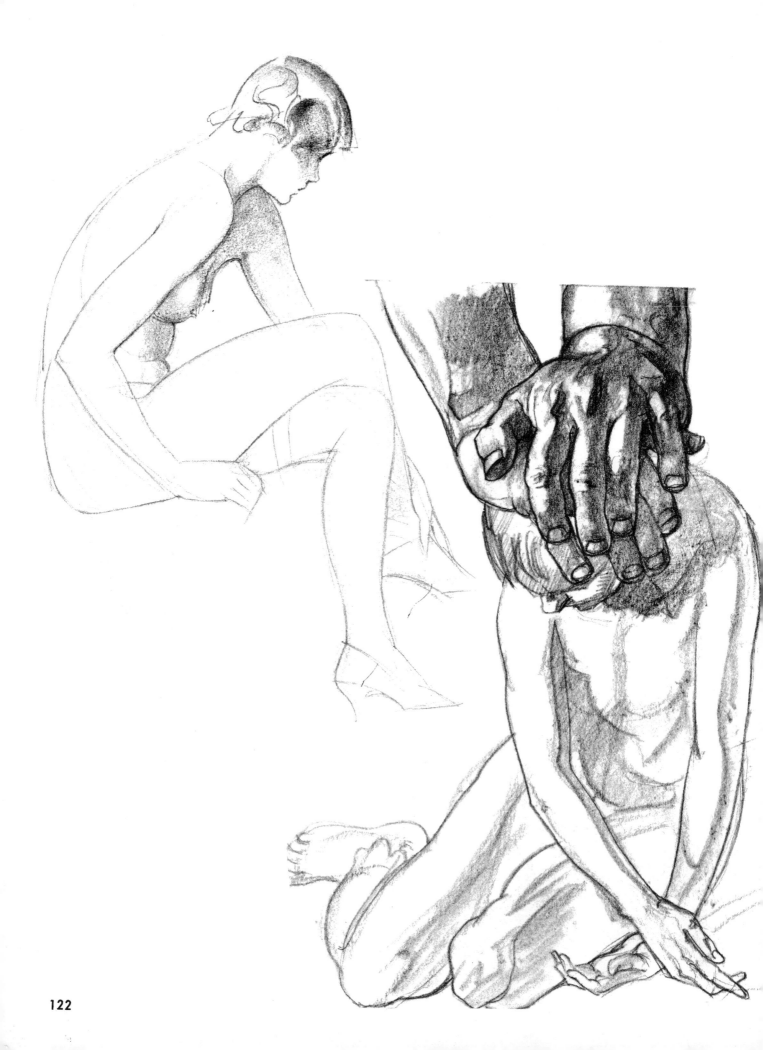

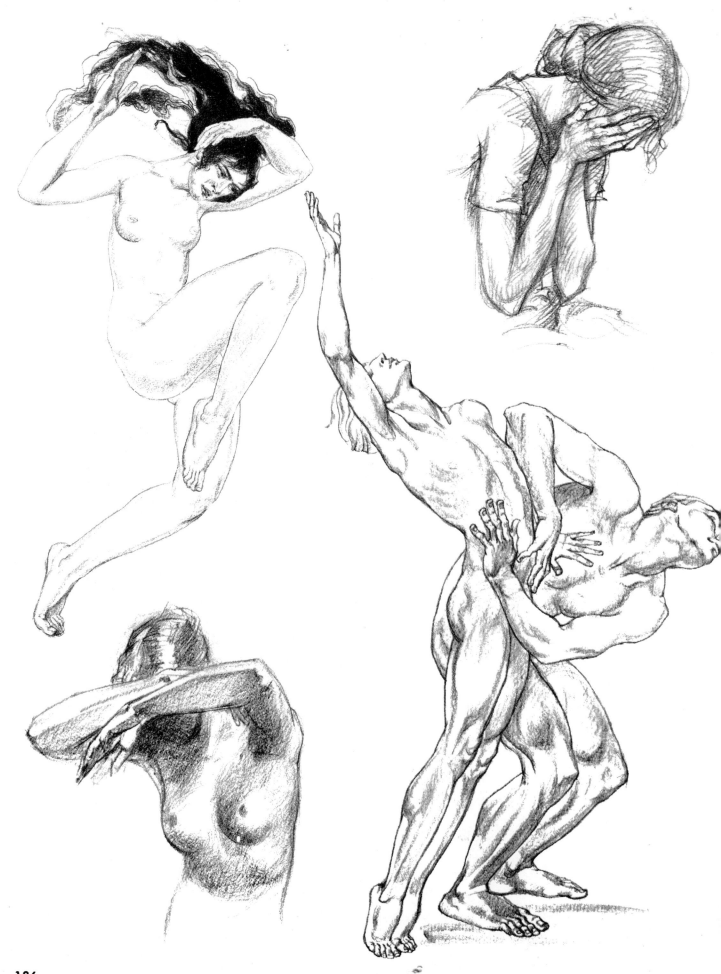

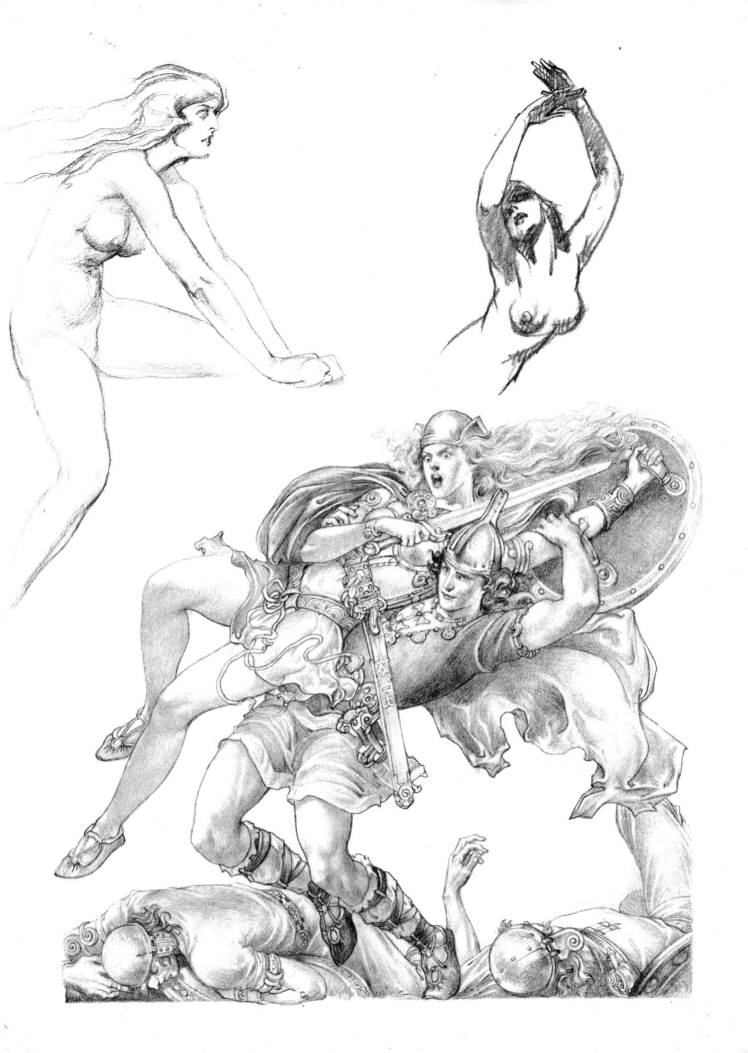